Anne Cullen-Tomsey

21st June 2014

A DENIM STORY

A DENIM STORY

Inspirations from Boyfriends to Bell bottoms...

BY EMILY CURRENT, MERITT ELLIOTT & HILARY WALSH

RIZZOLI
NEW YORK

New York · Paris · London · Milan

Introduction...

In life, it's rare to find people to take a journey with, let alone a creative one.

After meeting on our college campus, we bonded over a love of vintage Levi's 646s and the discovery that we both had been challenged by resources and the current market in expressing our fashion sensibility. We yearned for denim that in itself possessed ease—not too tight or trendy—as if it was not only a reflection of our fashion sense but more an offering from our rural upbringings and our effortless yet thoughtful dispositions. We found that we had relied, solely out of necessity, on Goodwill, Army Navy stores, local tack shops and the neighborhood tailor to achieve a cool, effortless look that not only got us through school, but also into our careers as burgeoning stylists. We have been bound by this vision for over a decade.

As we embarked on our professional careers, we were unimpressed with the sea of formulaic red carpet looks and overtly sexy denim ads and knew that we weren't relating to what was going on in fashion. We started to feel kindred to a sensibility that was more nostalgic, boyish, thoughtful and loved yet ironically cinematic and fantastical. We felt convinced that too many things lacked ease and casualness, and we yearned for a spirit of familiarity that was more personal and comforting. We wanted to revive our dads' old sailor pants and our moms' old bellbottoms, as they felt brazenly relevant and saturated with fascinating narratives. As stylists and designers we wanted to tell a story that echoed this relevance—through a jean, a collection, a red carpet look, an editorial. Often times this meant taking an old jean jacket to a tailor to fit a model for a photo shoot. Other times it meant dragging a pair of overalls through the mud to give them a more distinctive worn and authentic look. We paired denim with childlike dresses and circus-worthy costumes, we searched the earth for antique children's school boots and men's earnest oxfords to speak to the denim's versatility and restate its almost too-obvious timelessness and coolness.

When we met photographer Hilary Walsh, we were instantly smitten. She arrived at our first shoot in awkward-length Lee jeans from the 70s and an oversize men's denim shirt conservatively buttoned to the top and rebelliously frayed at the collar and cuffs. She came armed with extraordinary ideas and a contagious fervor. Also northern California natives, we immediately reveled in her immense talent and similar worldview. She, too, shared an obsession for all things indigo and, like us, is a storyteller, and loved to indulge in denim's timeless universality and unapologetically American coolness. We were all drawn to the same references; we leaned toward the same inspiration and rejoiced in the same simple nuances.

Hilary captured on film the denim we all cherished with unique compositions and within the environments it needed to live in. Some of our favorite shoots were, ironically and appropriately, in dilapidated trailer parks and on forgotten railroad tracks. She illuminated the beauty of this casual, beloved aesthetic, and, through dozens and dozens of collaborative photo shoots—each a different story—we became lifelong friends. Through the years, we have all shared our secret denim finds and exchanged unlikely inspiration found in everything from a patchwork indigo quilt to an image of a fieldworker in a denim jacket from the turn of the century. We have continued a special conversation that has both enriched our lives and fueled our creativity.

In defining our aesthetic, we discovered ourselves. We had all begun an intense love affair with denim—with both its history and potential—that inspired our approach to styling and design, photography and life. We have unearthed profound inspiration in old photographs, ranging from a child in overalls to a railroad worker, that both engage and thrill us. We have created imagery that is viscerally familiar yet overtly relevant. We pride ourselves in being contrary to what the world often pigeonholes as "fashion" or "feminine," instead being inspired by boyish silhouettes, the Dust Bowl era and the *Boxcar Children* series. As all three of us are kindred storytellers, we have re-discovered the youthful sensation of ease peppered with optimism and celebrate imagery that feels familiar—as if you not only have seen it before, but were there and long to return.

Every pair of jeans has a story and tells a story. We fancy ourselves storytellers—people who imagine—then create compelling worlds. As stylists, we create fashion stories and as designers, we create storyboards and color stories. As a photographer, Hilary envisions stories, shoots stories, and captures stories. This book celebrates the many ways denim has inspired our story and how it has played such a significant part throughout history and in so many people's own personal stories.

And this book, in essence, is our story.

With love and style,
Emily Current & Meritt Elliott

Table of Contents

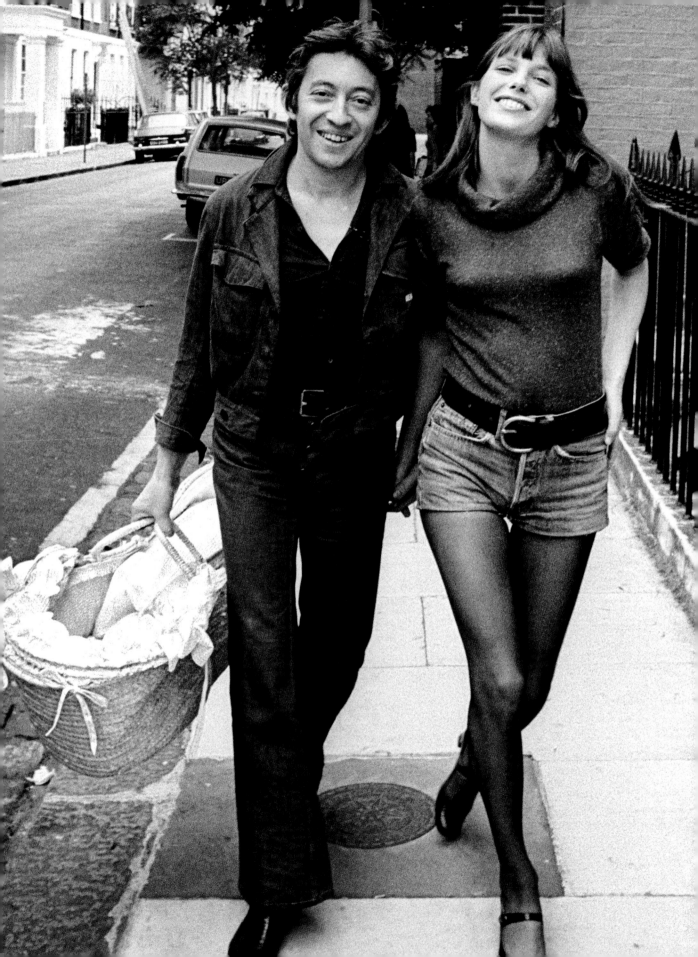

A love Story

Loving a pair of jeans is like loving a person. It takes time to find the perfect one and requires care and mending to make it last. And while new love can be exciting, like jeans, it can be all the better with age. We adore denim that looks and feels "loved" like it's been worn and washed a million times. We similarly are drawn to imagery that celebrates love in viscerally simple ways. It's beautiful between a couple, but equally as precious between two friends, a mother and son, or two young children.

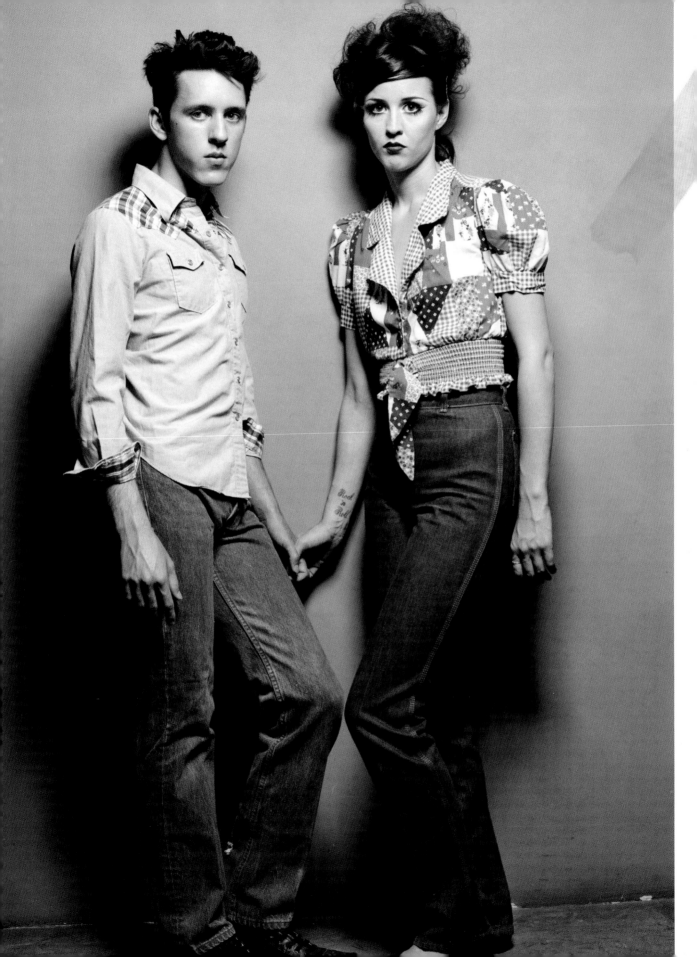

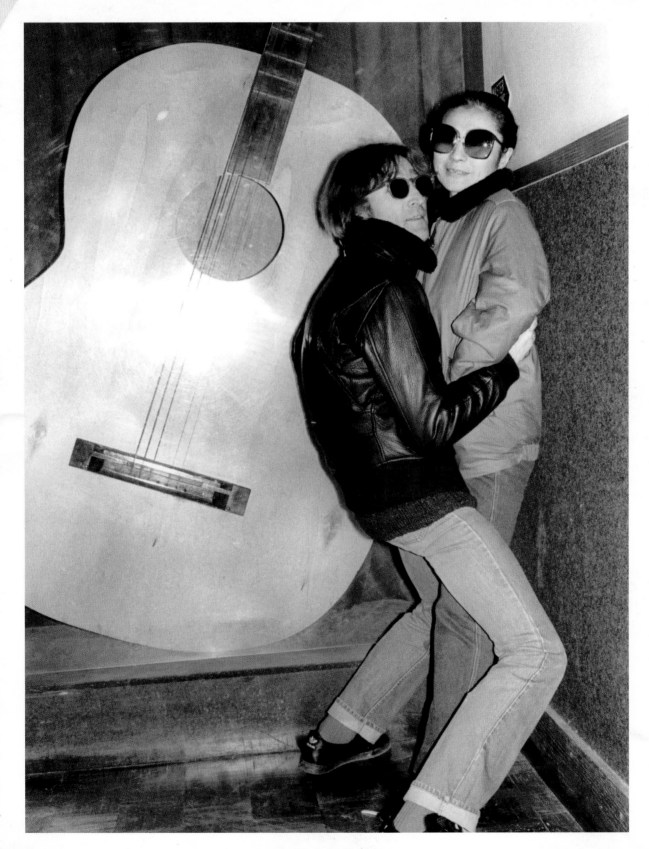

JOHN AND YOKO

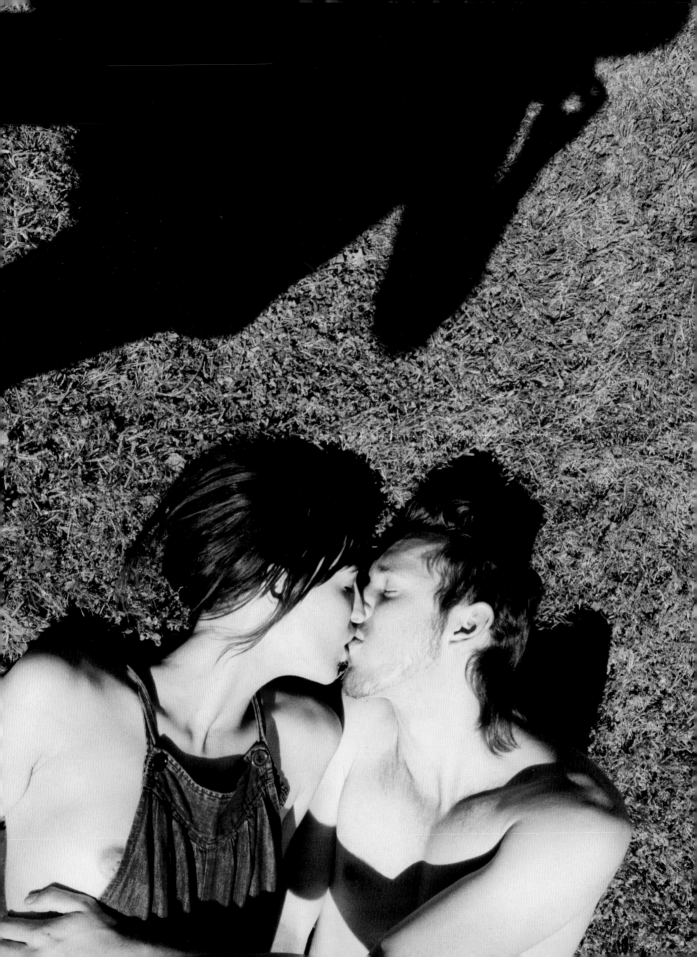

RONNY AND JULIE

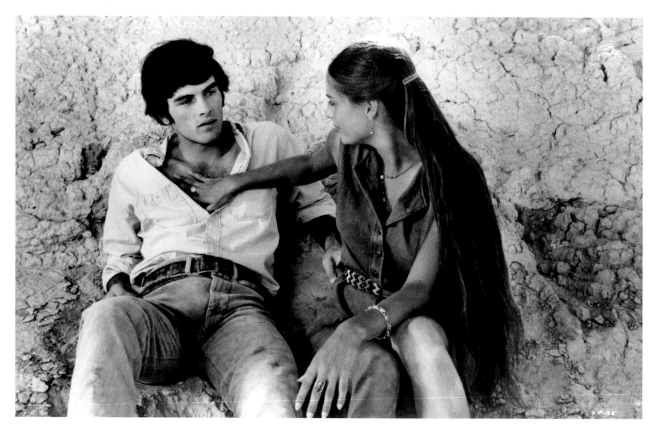

MARK FRECHETTE AND DARIA HALPRIN

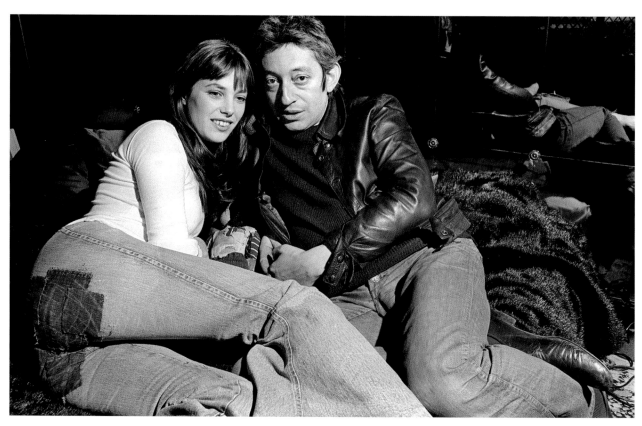

JANE BIRKIN AND SERGE GAINSBOURG

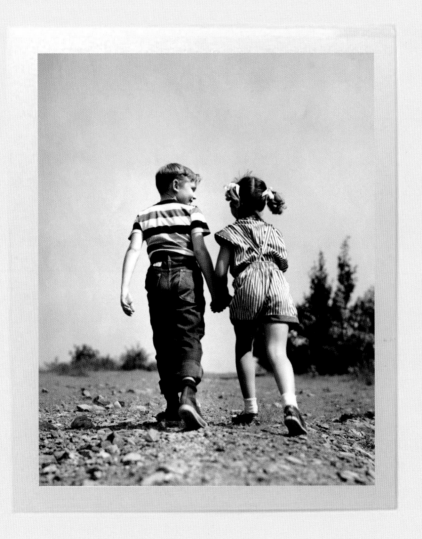

THESE TWO CHILDREN REMIND US OF WHEN LOVE WAS SIMPLE
AND FULL OF UNEXPECTED ADVENTURE.

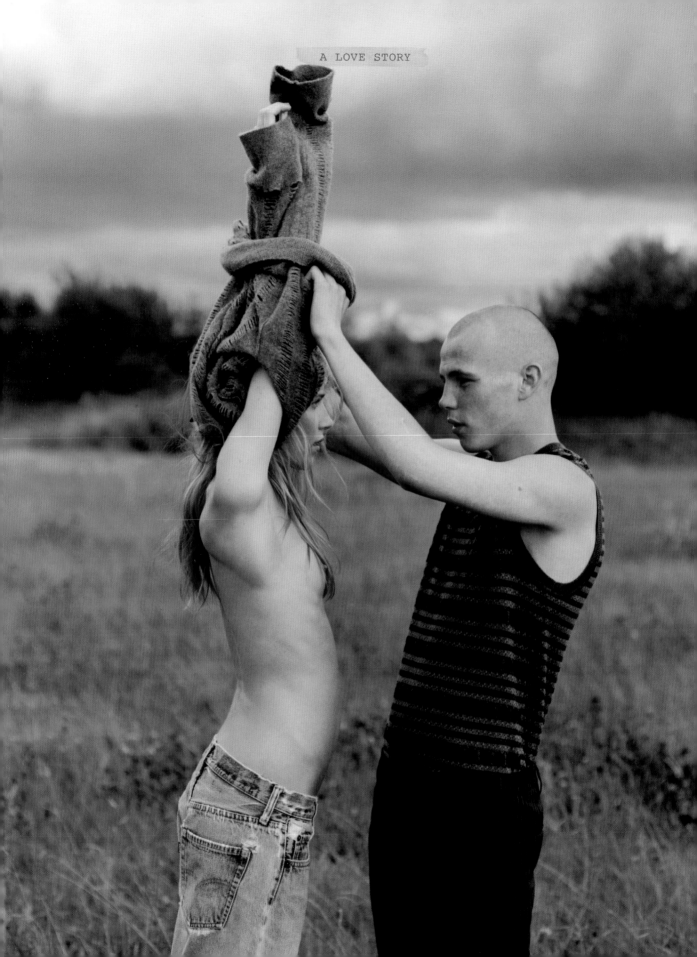

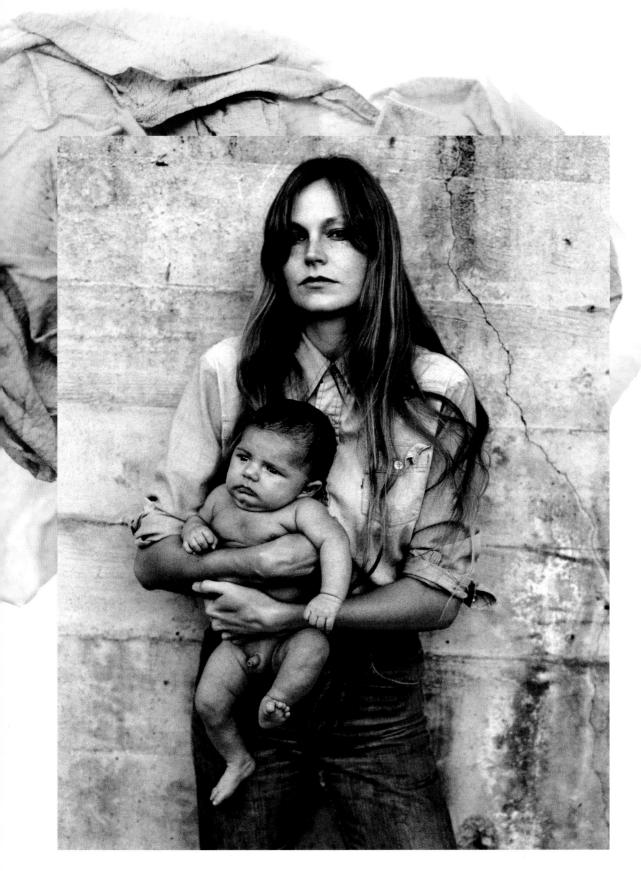

MOTHERHOOD HAS BEEN MAGICAL FOR US, OUR SWEET BABIES PROVIDING US ENDLESS
INSPIRATION IN OUR WORK. IT HAS RENEWED OUR NEED FOR THINGS TO FEEL SOFT AND
FEEL EASY, AND TO ENDURE DAYS OF PLAY AND ADVENTURE.

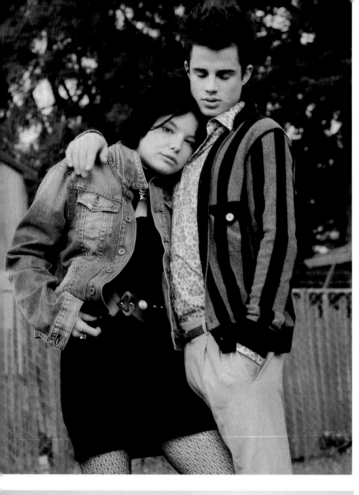
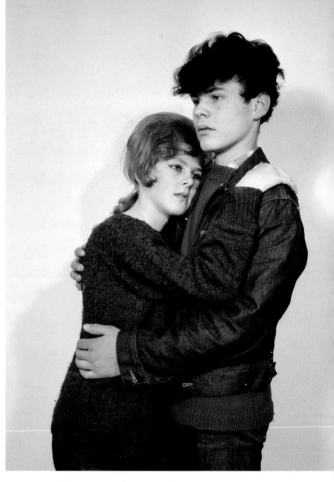
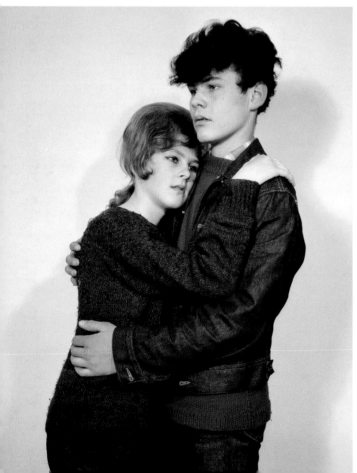
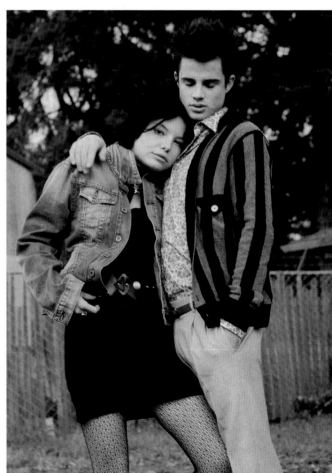

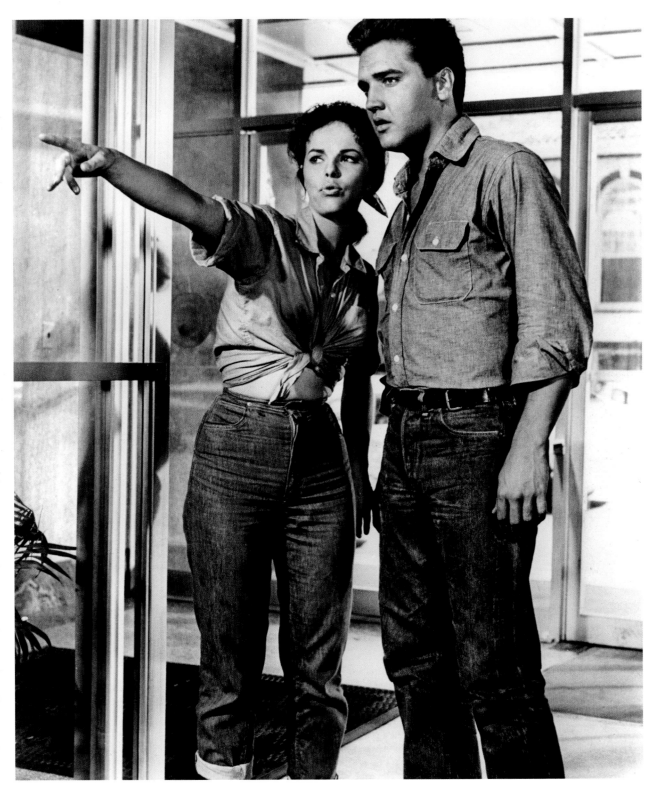

WE ARE AS FASCINATED BY ELVIS'S LOVE LIFE AS WE ARE
BY THE FACT THAT THESE TWO ARE BOTH CLAD IN DOUBLE
DENIM. THE WOMAN IS DRESSED TO DEFINE THE CURVES OF
HER FEMININITY, WHILE ELVIS IS DRESSED TO CAPTURE HIS
FAMOUS REFINED RUGGEDNESS.

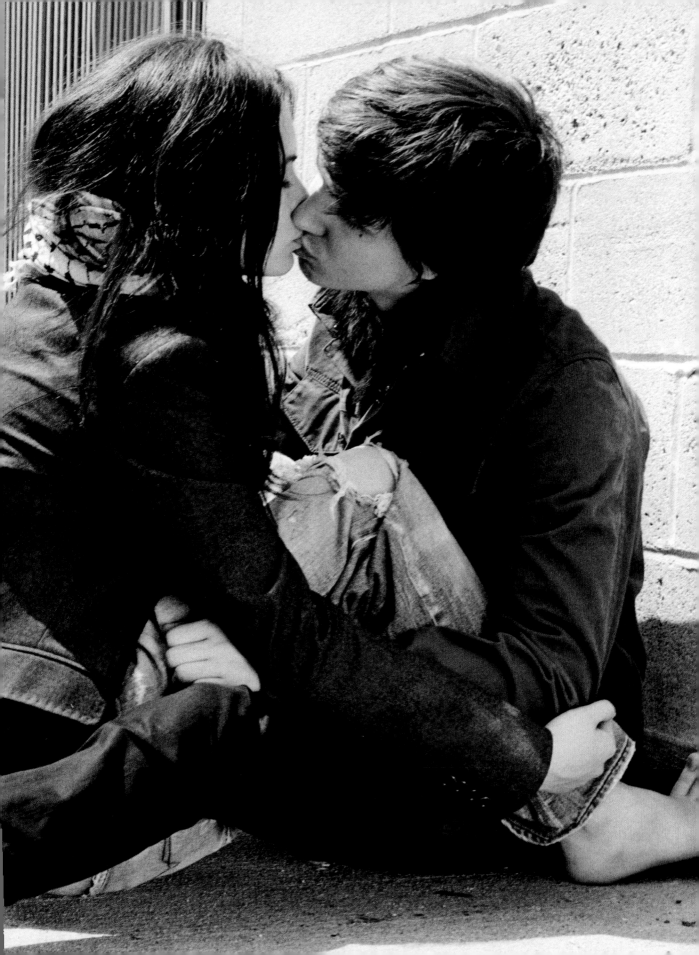

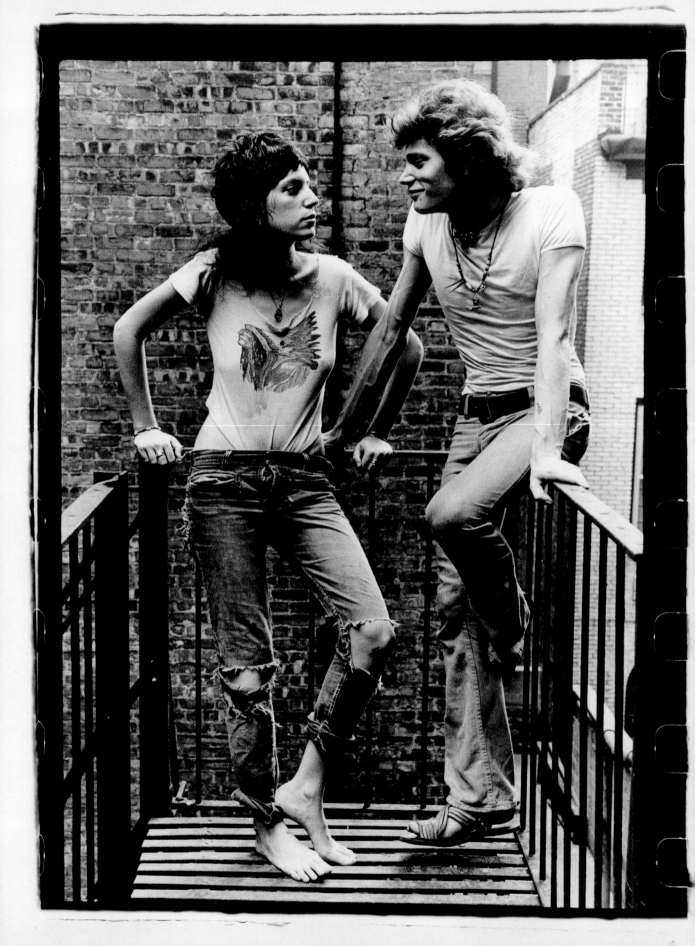

THROUGHOUT HIS FASCINATING LIFE, ROBERT MAPPLETHORPE HAD A LOVE AFFAIR
WITH ONLY ONE WOMAN, PATTI SMITH. THEIR ANDROGYNY WAS ALMOST PALPABLE, IN
EVERYTHING FROM THEIR HAIR TO THEIR JEANS TO THEIR TORTURED RELATIONSHIP.
SHE WAS HIS MUSE IN SO MANY WAYS, AND WE ARE ENAMORED OF THEIR UNIQUE
LOVE THAT FUELED BOTH GREAT PHOTOGRAPHY AND MUSIC.

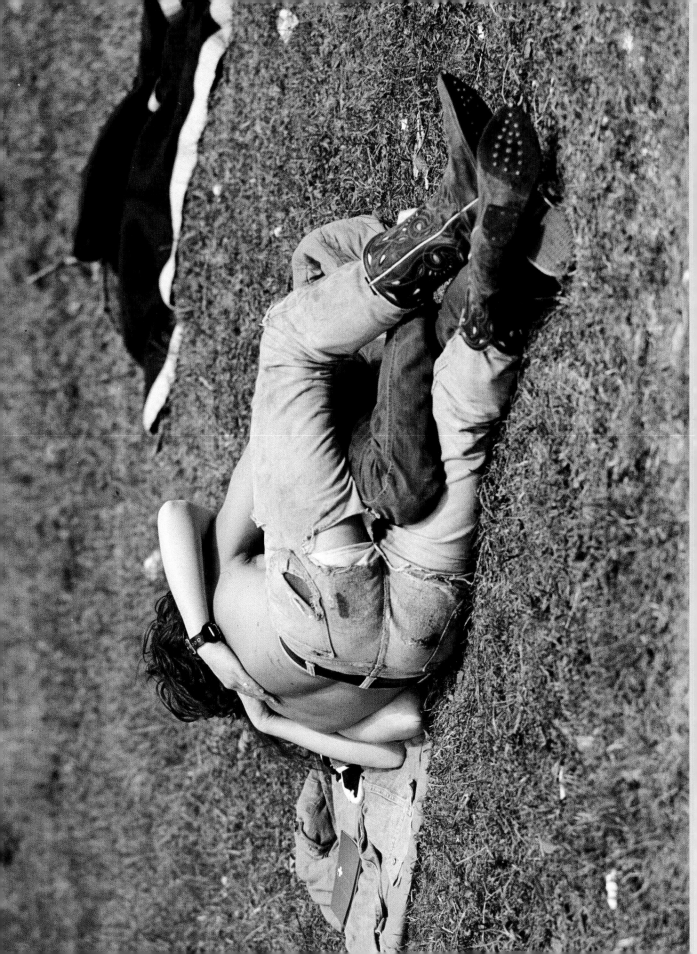

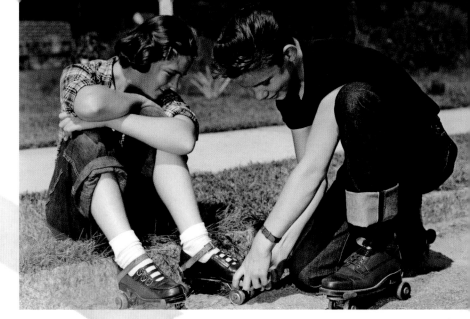

WE OFTEN PREFER WHEN PEOPLE IN DENIM ARE
CAPTURED IN BLACK AND WHITE. WITHOUT
COLOR, THE WEAR AND WASH OF A FABRIC IS
ILLUMINATED, AS WELL AS THE DISPOSITION
OF THE PEOPLE WEARING IT—WHETHER IT BE
INDIFFERENCE, PASSION, OR CONFIDENCE.

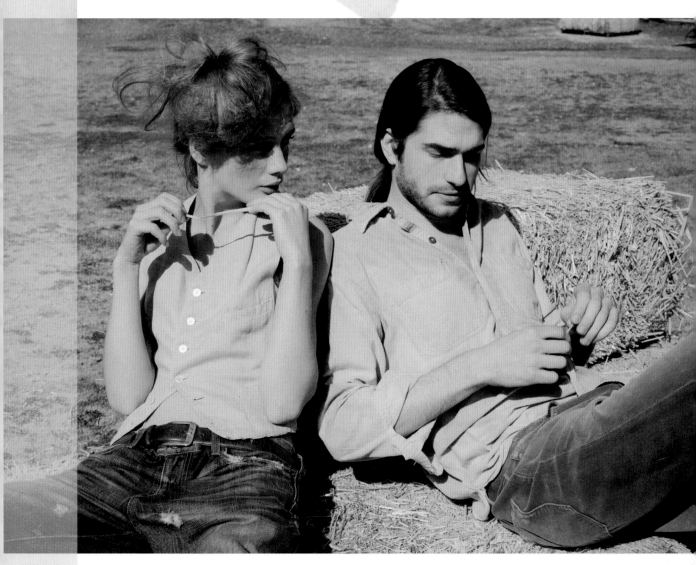

ANNA AND TONY

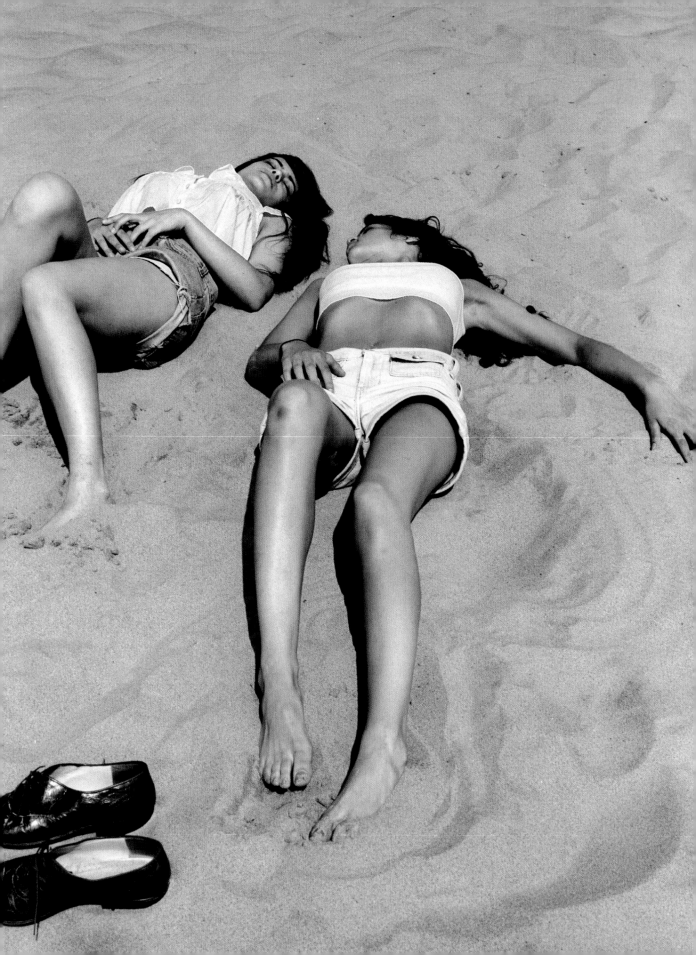

The notion of an American summer

evokes imagery that is quintessentially denim. We can nearly smell an outdoor barbecue, hear a classic rock band in the park, and feel the warmth of a beach bonfire, all in our cutoff 501s. As kids, we reveled in an endless summer day—doodling our crushes' initials on our favorite jean jackets and watching the holes in the knees of our jeans grow with character and quietly whisper sweet summer stories.

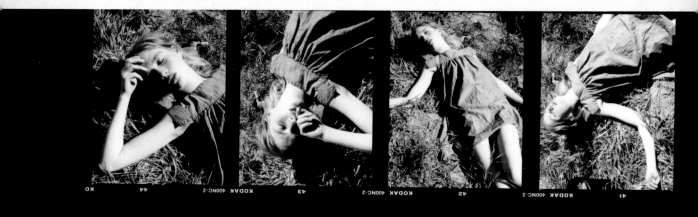

HILARY WALSH / CURRENT ELLIOT 14582-63

WE FIND DENIM TO BE MOST COVETABLE WHEN EXPOSED TO THE SUMMER ELEMENTS—
A SANDBLAST, A SUN FADE, AND THE SOFTNESS FROM SALTWATER.

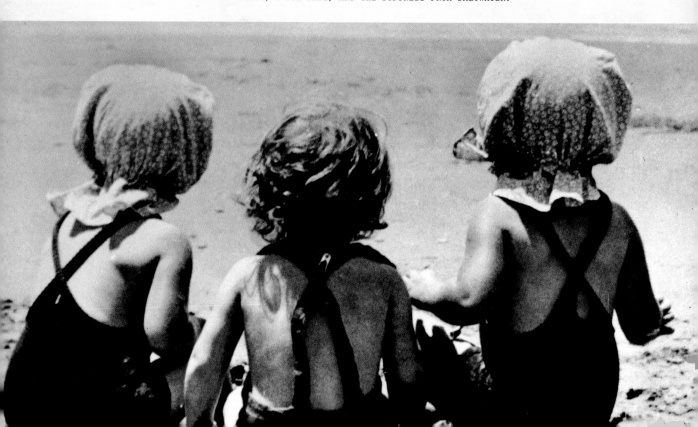

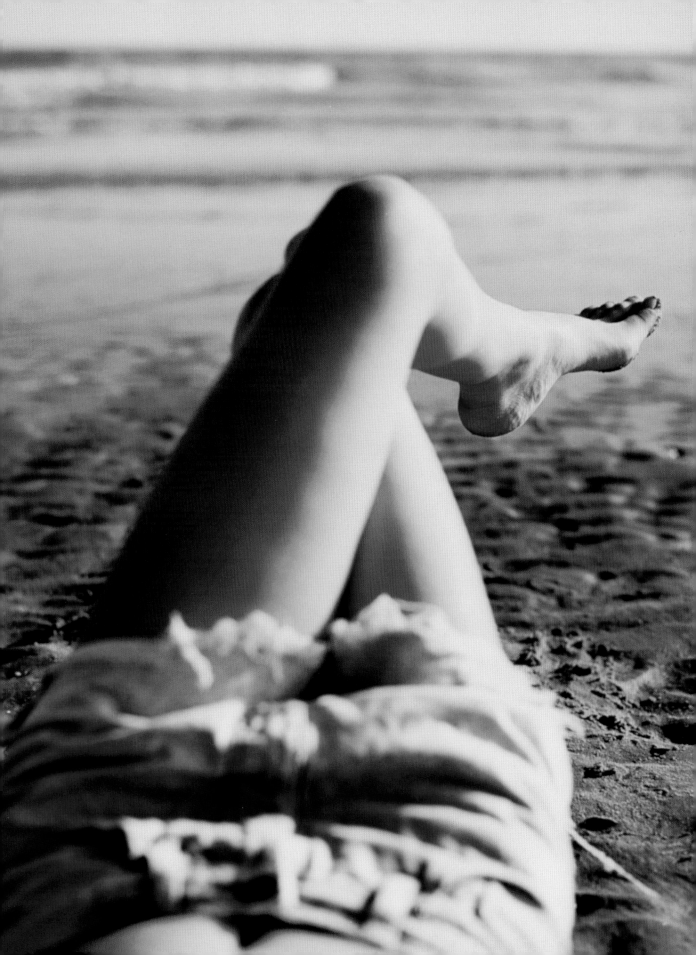

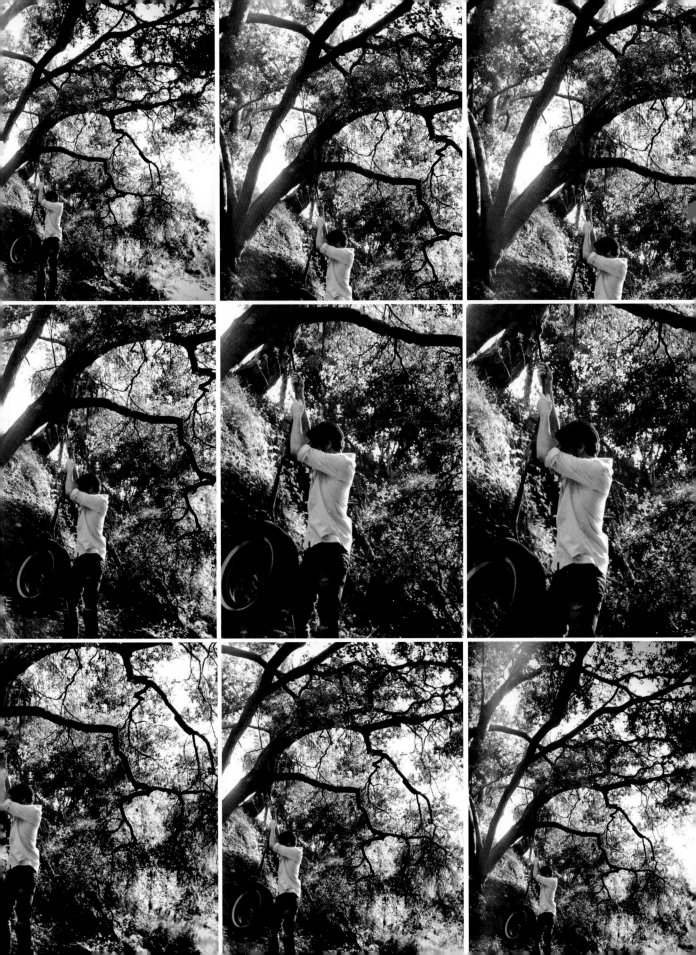

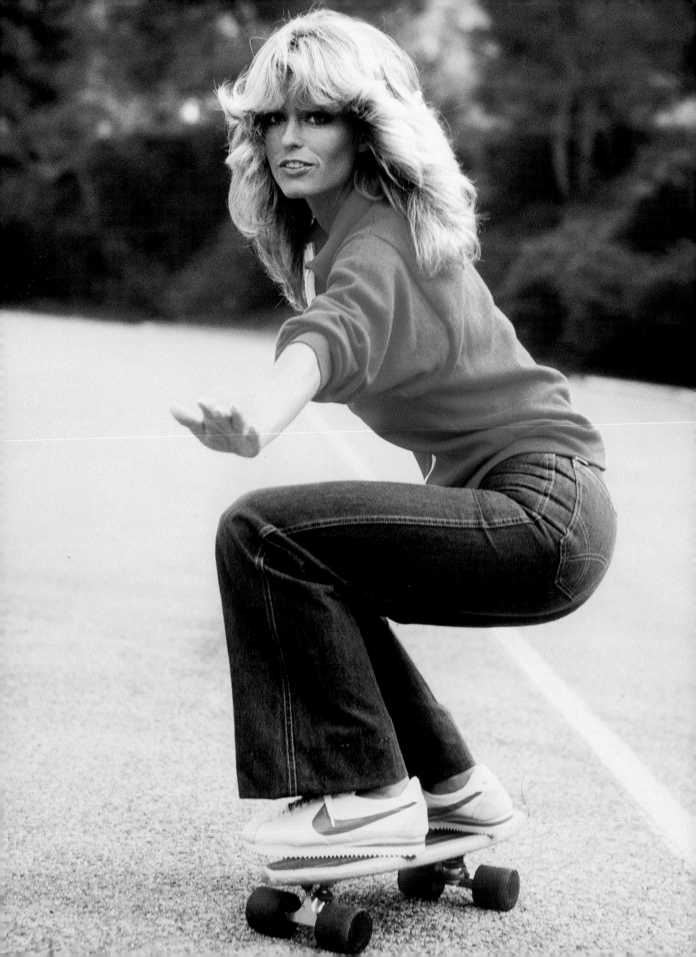

THIS 1976 IMAGE OF FARRAH FAWCETT IS ICONIC, TOTALLY
DEFINING AN ERA WHEN WOMEN WERE BOTH LIBERATED AND CELEBRATED
FOR THEIR FEMININITY. FARRAH MANAGES TO LOOK ULTRA-FEMININE
EVEN IN THIS TRADITIONALLY BOYISH ATTIRE AND SETTING.

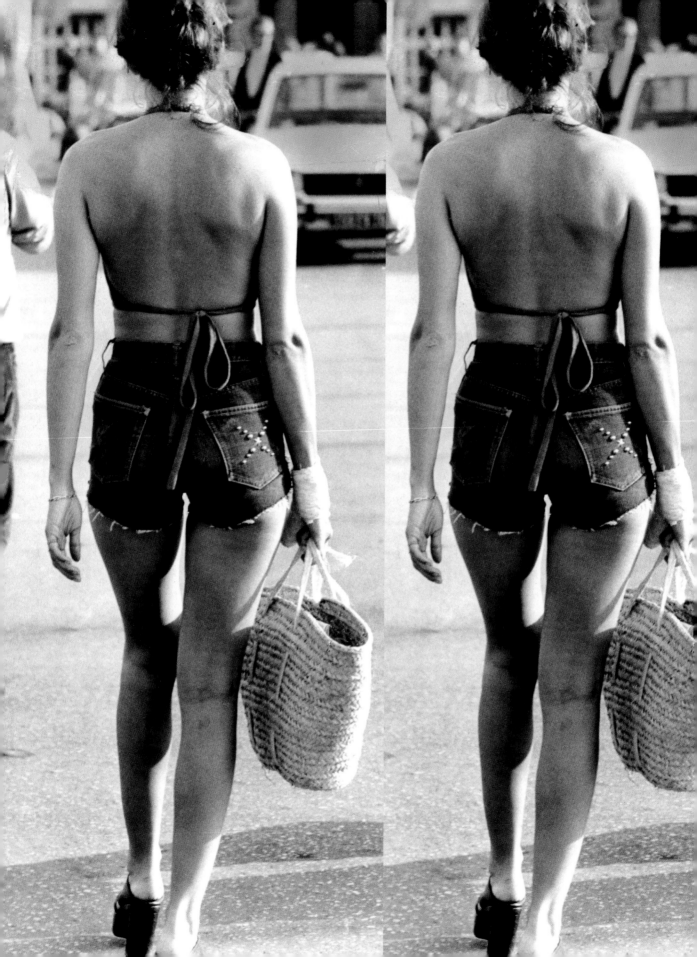

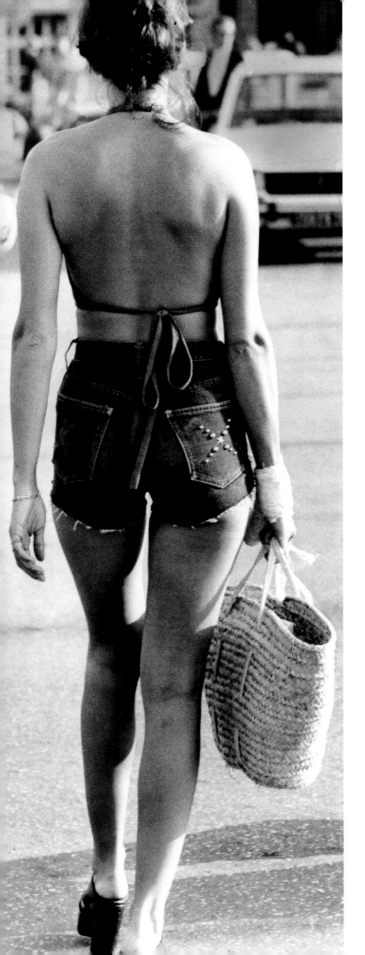

DENIM IS THE PERFECT MEDIUM FOR SELF
EXPRESSION. A FRAYED HEM, ADDED HARD-
WARE OR A RIPPED-FROM-HIS-HAND POCKET
SPEAKS TO WHAT JOURNEY THE JEANS, AND
THE GIRL, HAVE BEEN ON.

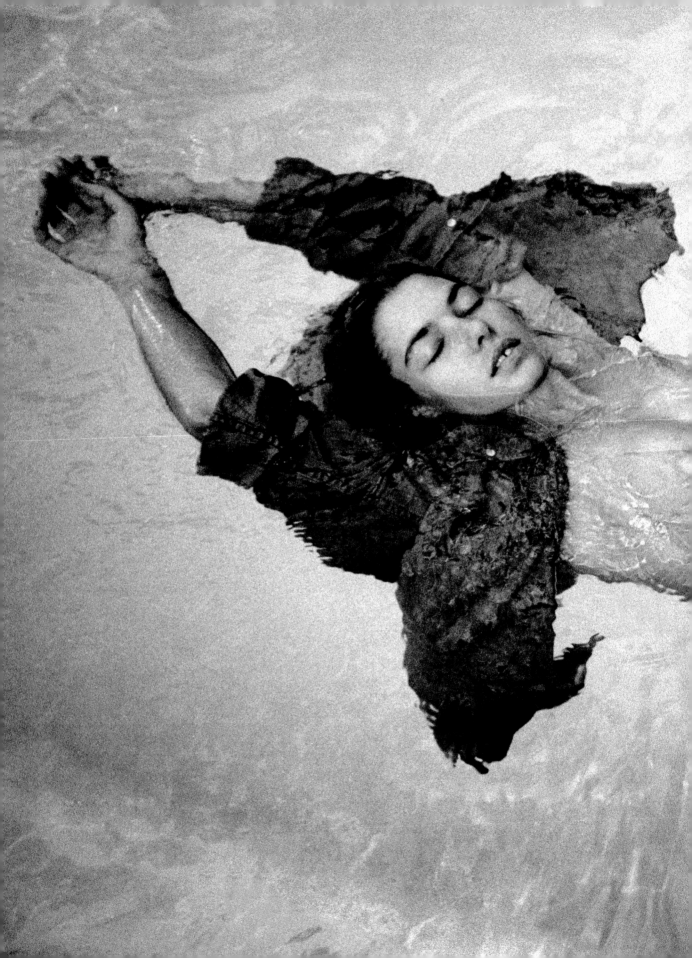

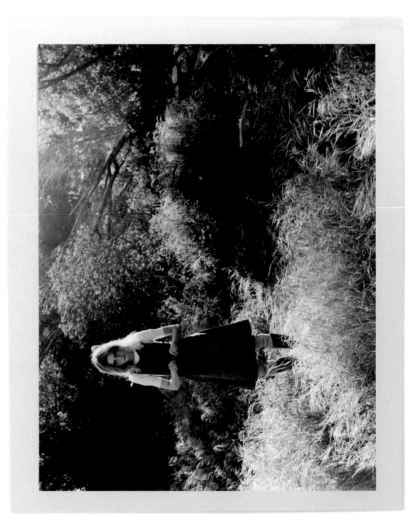

A DENIM DRESS IS THE BEST KIND OF IRONY.

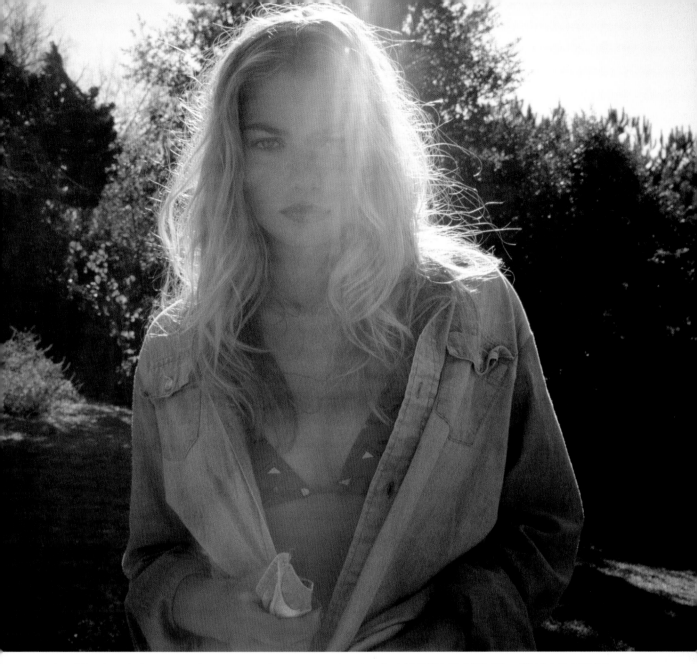

A GIRL SWIMMING IN DENIM OVER A BATHING SUIT PROVOKES AN IRONIC FEELING OF BOTH BRAZENNESS AND MODESTY.

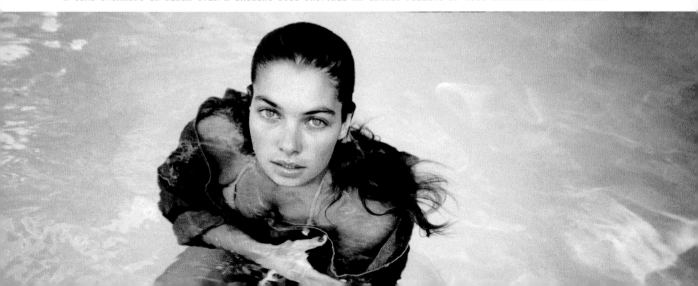

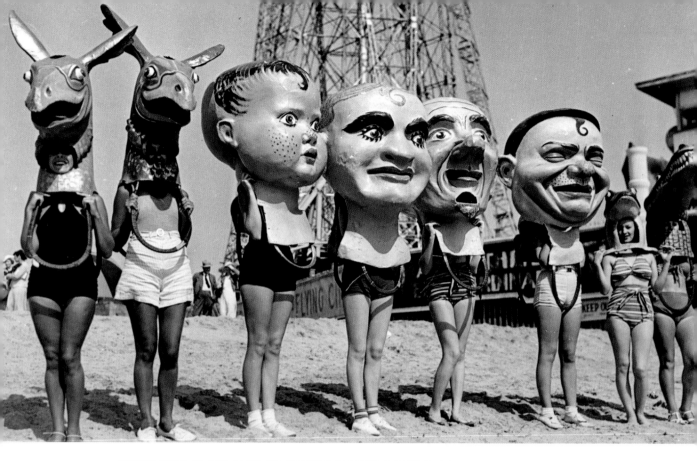

PLAYING DRESS UP WITH MASKS AND COSTUMES HAS BEEN A RECURRING THEME THAT INSPIRES OUR WORK,
ESPECIALLY IN THE SUMMERTIME WHEN WE ARE ALL AT OUR MOST PLAYFUL AND IRREVERENT IN OUR DRESS AND DISPOSITION.

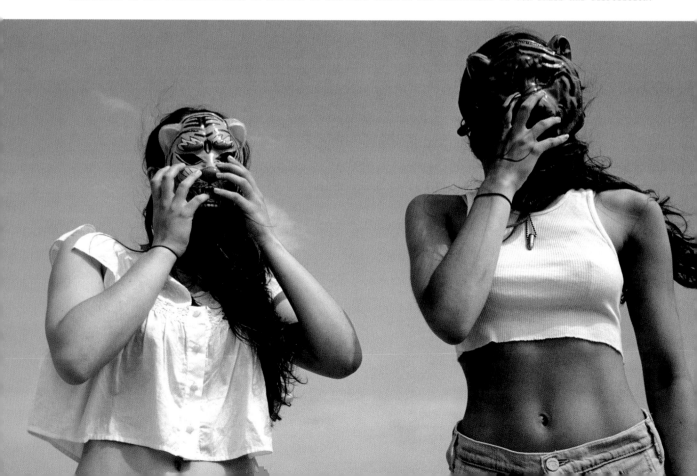

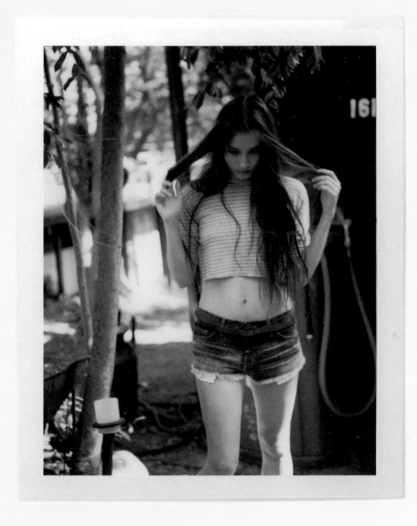

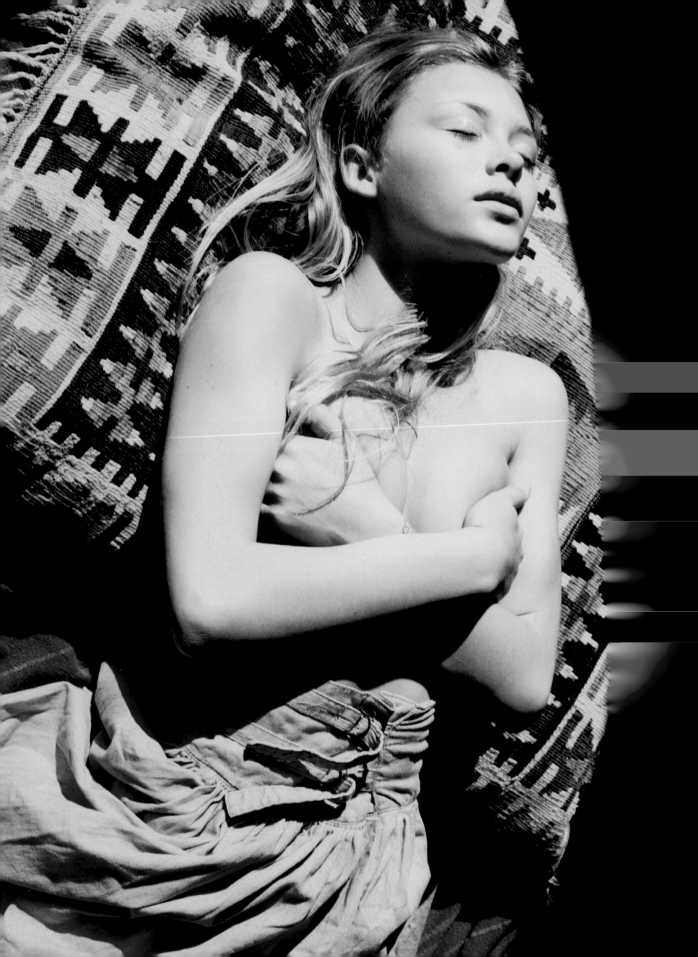

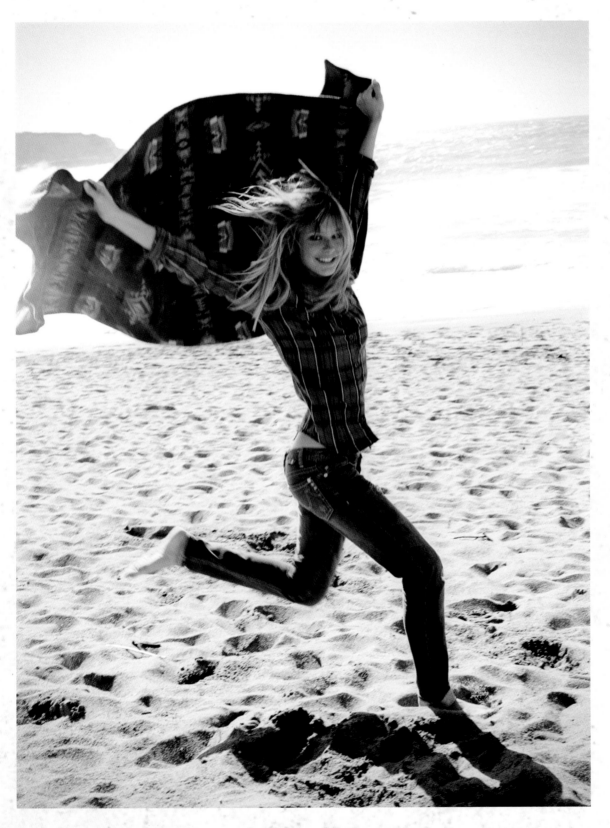

DAYDREAMING TURNS THE BOREDOM OF A LONG SUMMER DAY INTO A QUIET MOMENT OF ESCAPE OR INSPIRATION.

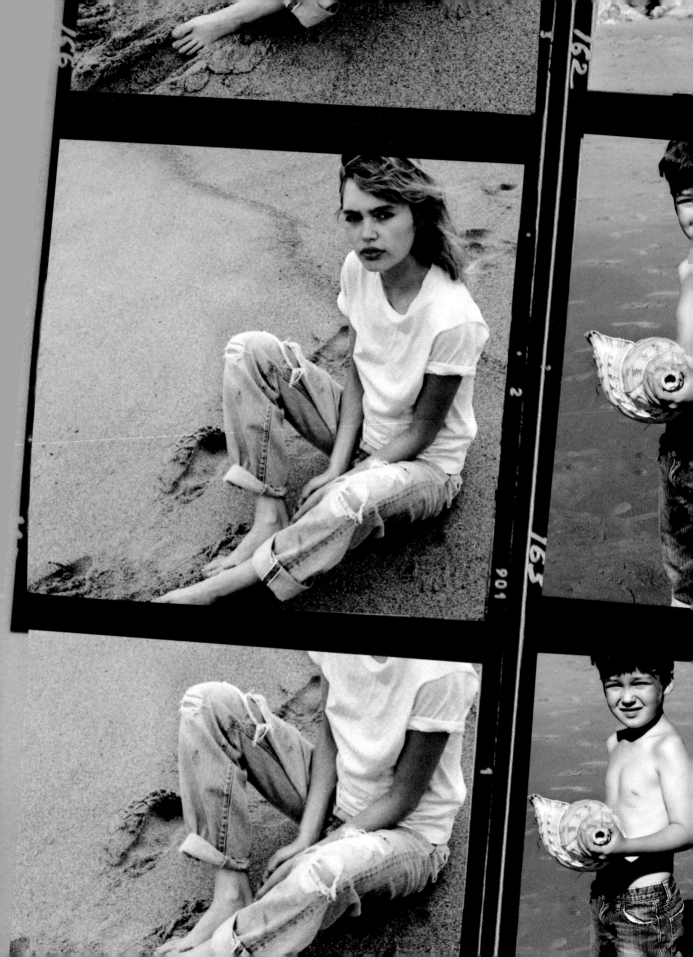

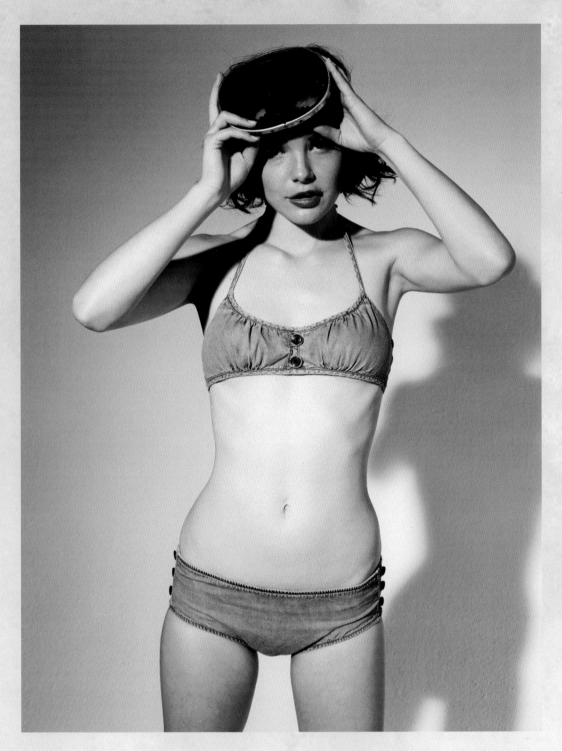

DENIM IS MORE THAN A PAIR OF JEANS: IT IS A MEDIUM FOR CREATIVE
EXPRESSIONS-IN THIS CASE A SWEET INDIGO BIKINI.

INTERNATIONAL QUILT STUDY CENTER & MUSEUM, UNIVERSITY OF
NEBRASKA-LINCOLN, 2000.004.0022

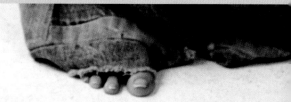

wash, wear, repair

wash, wear & repair

Wash, Wear & Repair

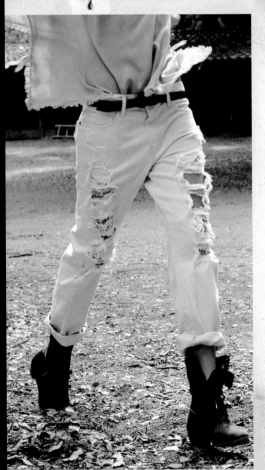

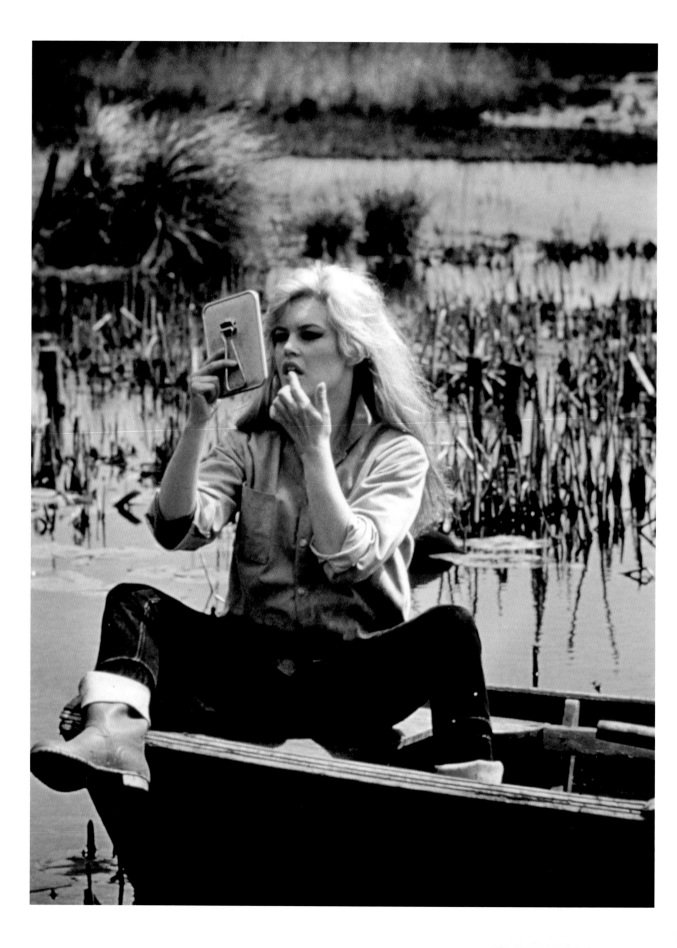

A Girls' Guide to Hunting & Fishing

There is an adventurous side to girls

like us-camping, fishing, hiking-wearing hand-me-down denim two sizes too big or too small, and then impulsively cutting them into shorts. It's amazing how such adventurous girls can accidentally be iconically stylish. The effortlessness of a rolled cuff to wade in a river or a popped collar to protect from the sun is authentically and timelessly cool.

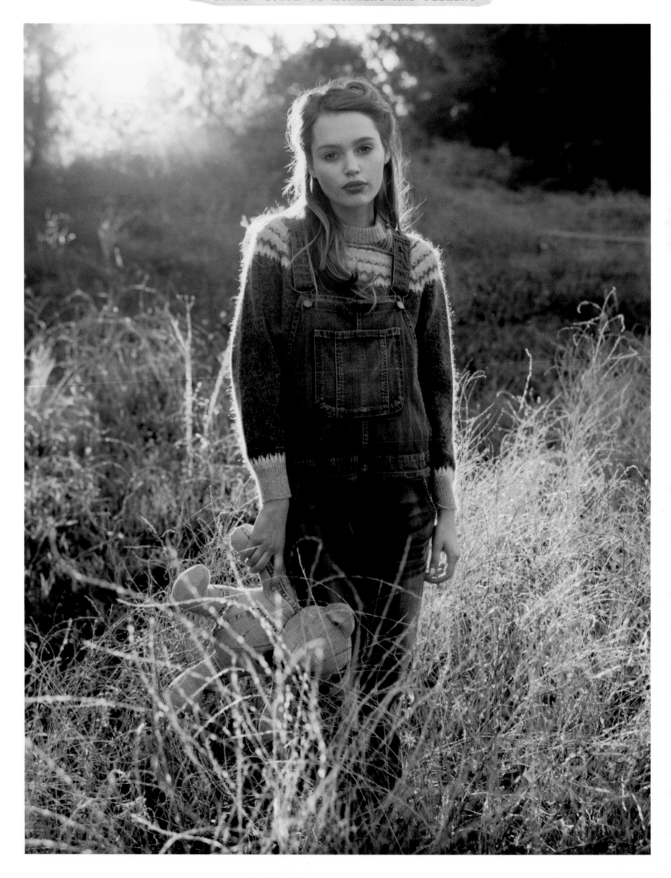

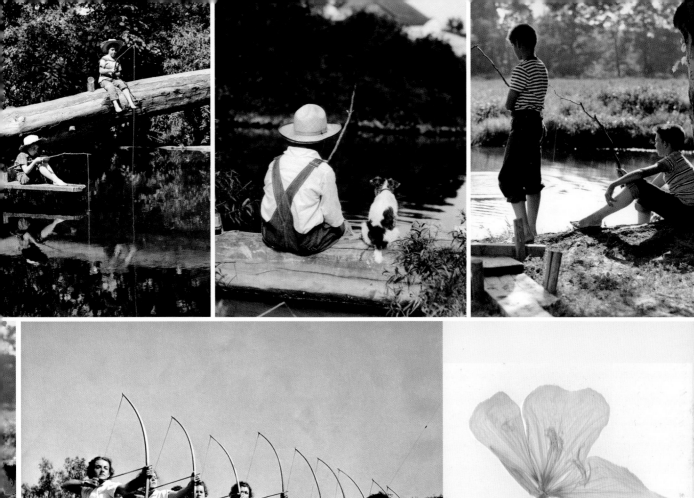

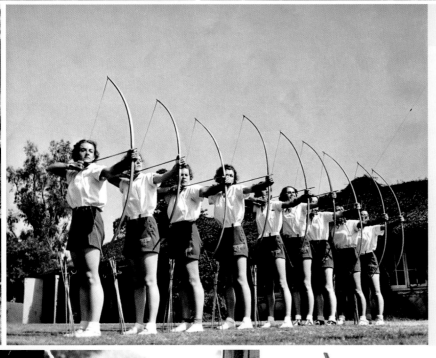

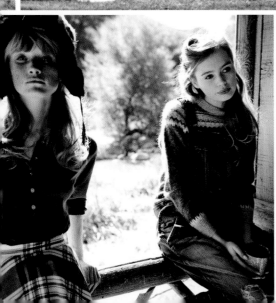

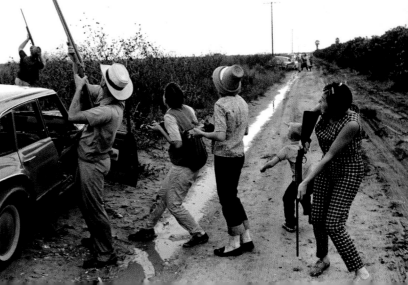

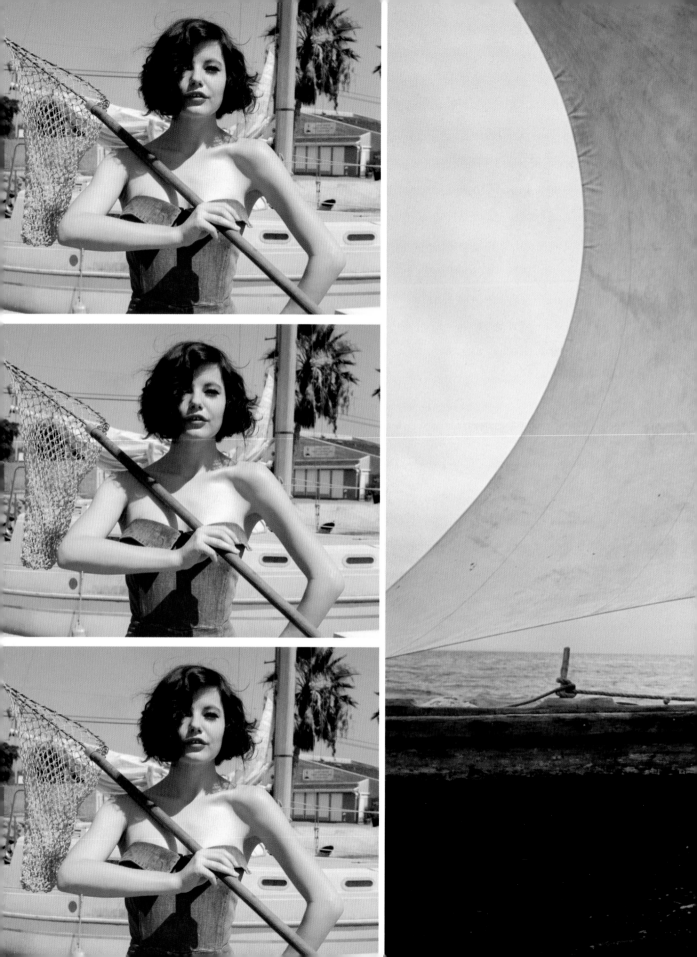

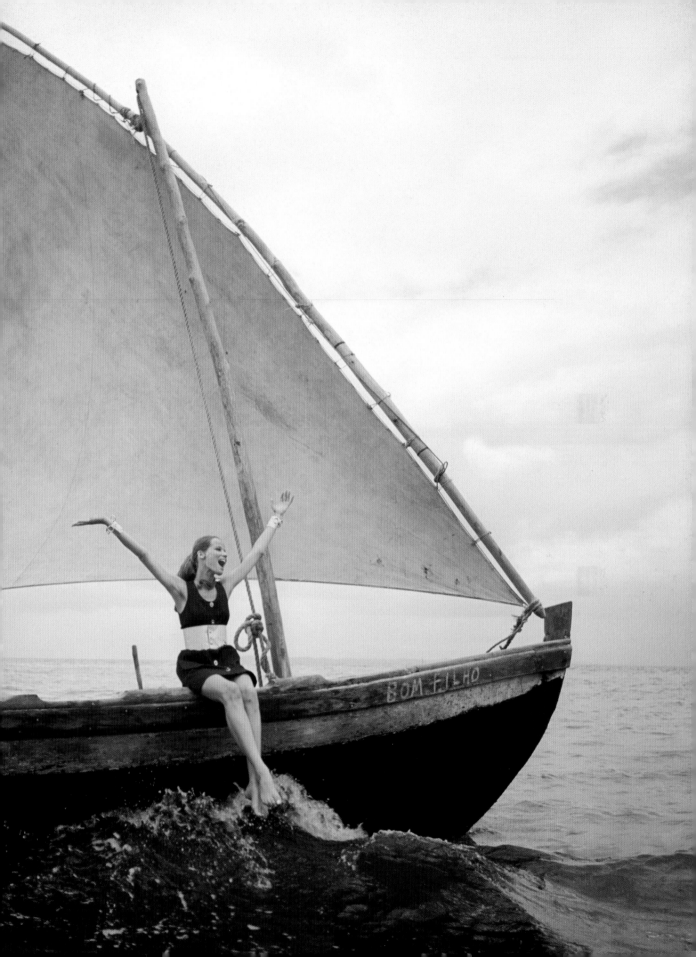

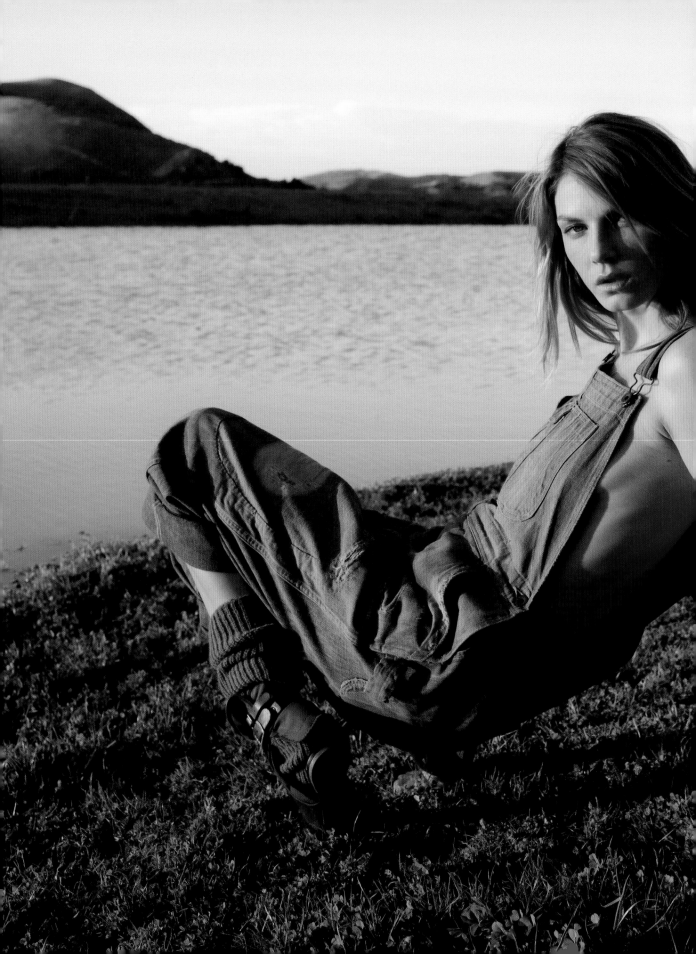

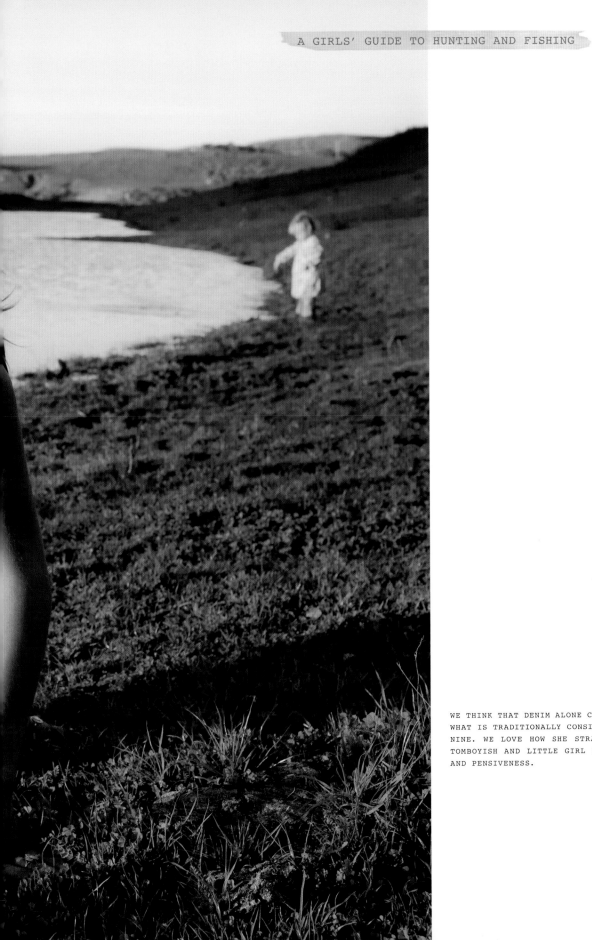

WE THINK THAT DENIM ALONE CAN REDEFINE
WHAT IS TRADITIONALLY CONSIDERED FEMI-
NINE. WE LOVE HOW SHE STRADDLES BOTH
TOMBOYISH AND LITTLE GIRL PLAYFULNESS
AND PENSIVENESS.

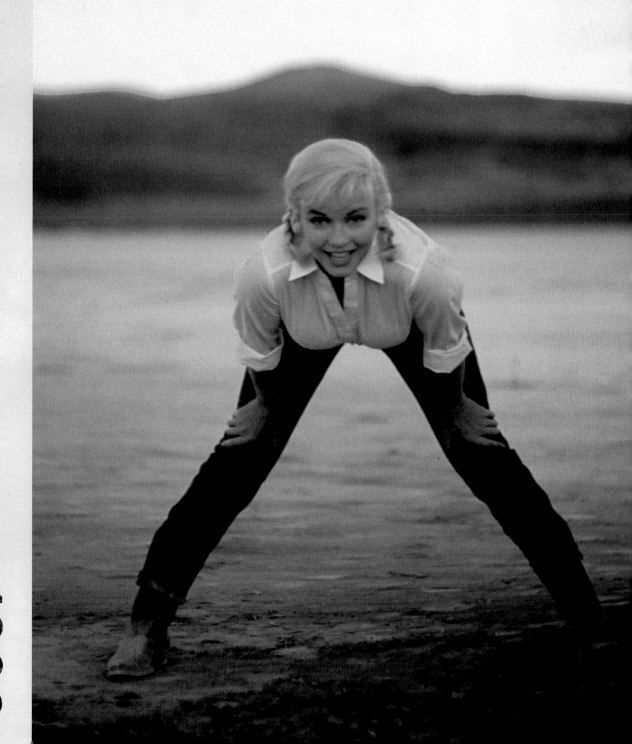

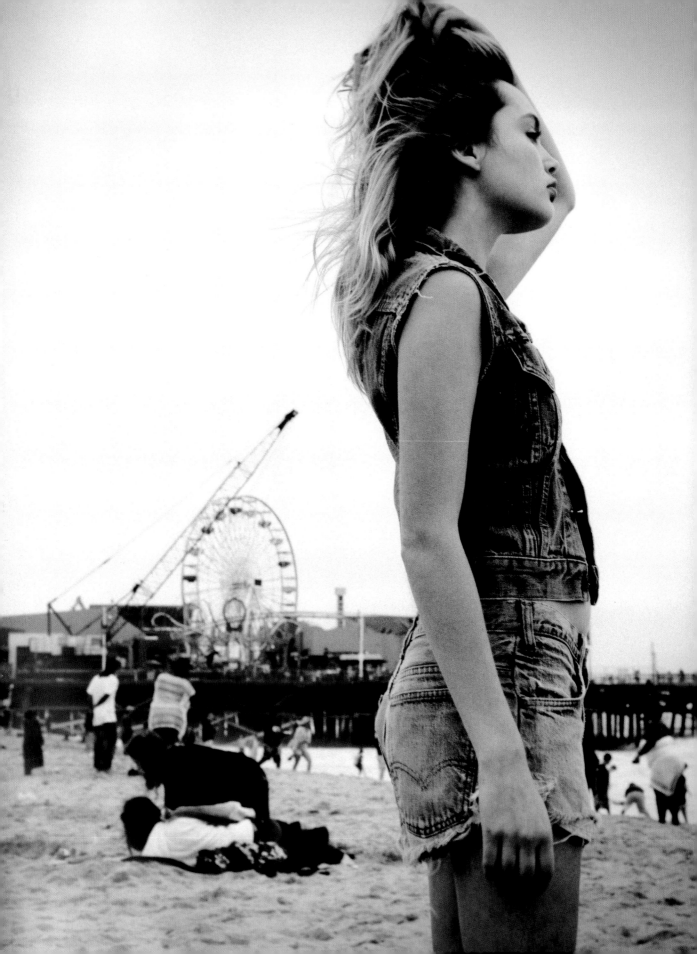

Circus

We are endlessly enamored of the beautiful irony
of denim paired with fantastical settings and costumes. We are inspired
by the dusty austereness of old theatrics—from the threadbare stripes of
dare-devils to lion tamers' bright costumes, from the sun-faded primary
colors of old Ferris wheels to the unlikely shimmer of golden hay bales.
Whether it is through a garment, an outfit or an image, it is simply magical
to capture the childlike spirit of the circus-goer's wonder and amazement.

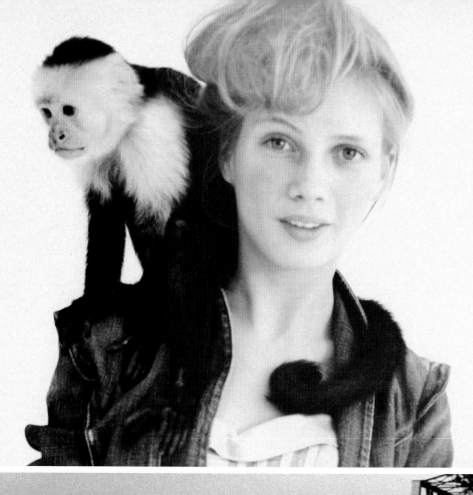

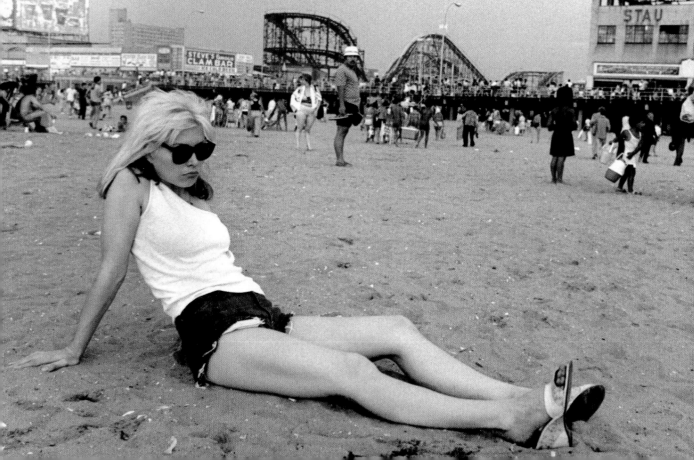

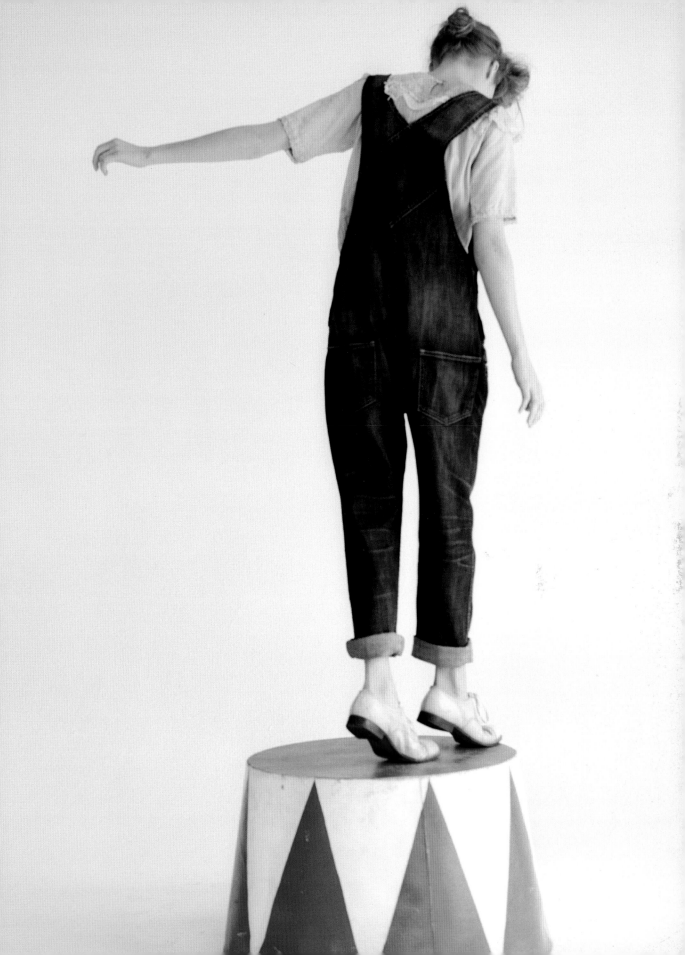

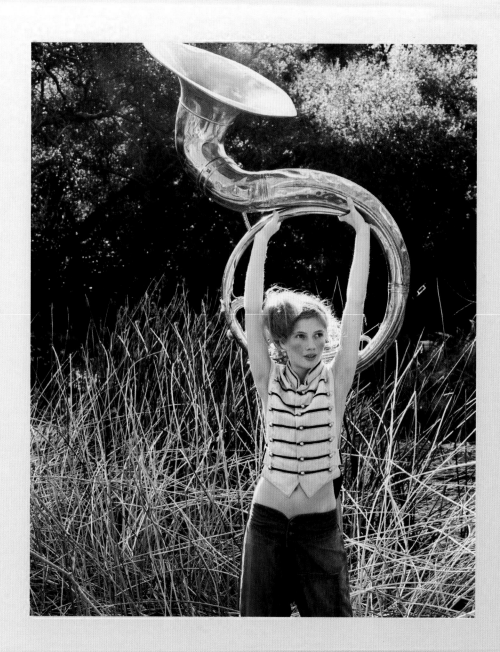

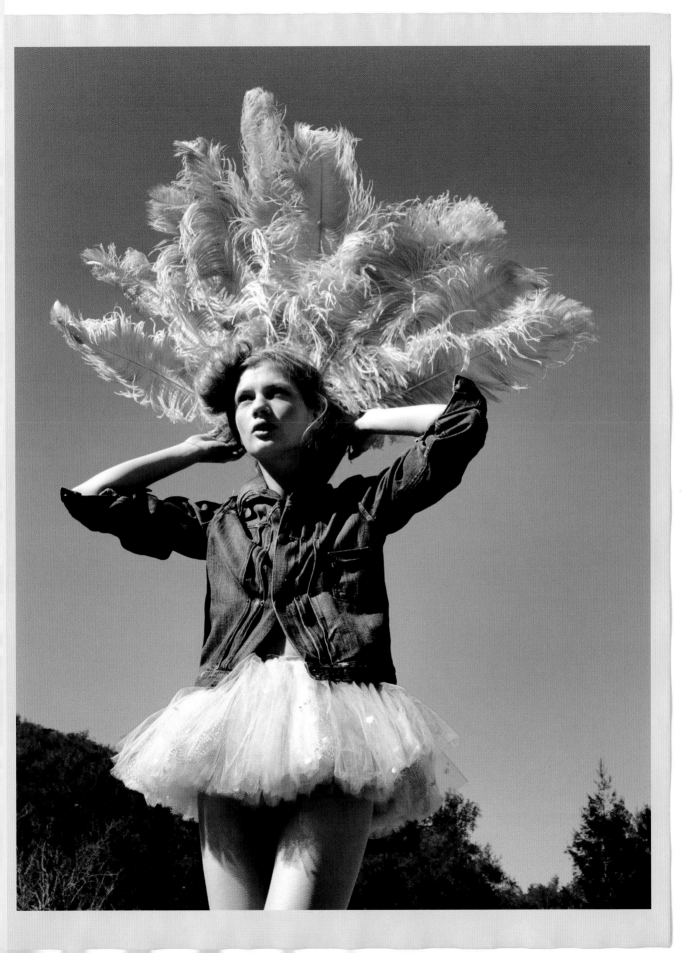

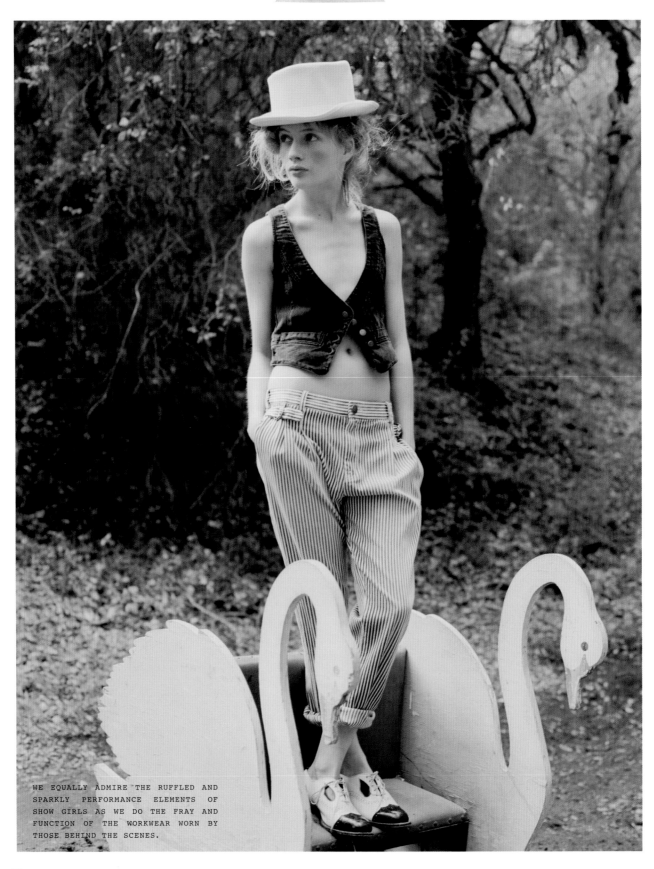

WE EQUALLY ADMIRE THE RUFFLED AND
SPARKLY PERFORMANCE ELEMENTS OF
SHOW GIRLS AS WE DO THE FRAY AND
FUNCTION OF THE WORKWEAR WORN BY
THOSE BEHIND THE SCENES.

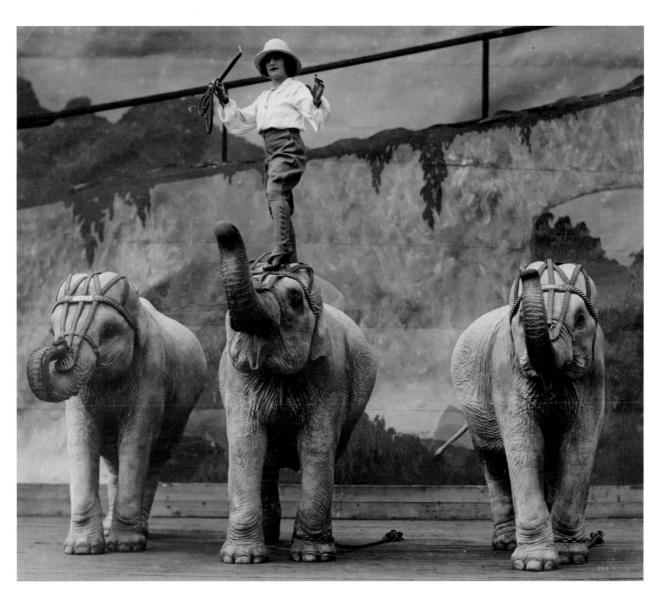

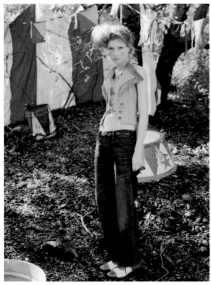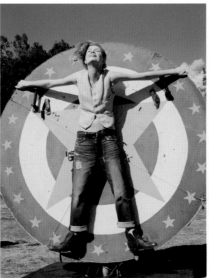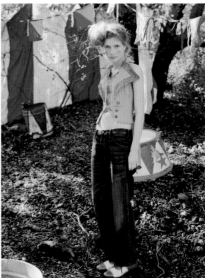

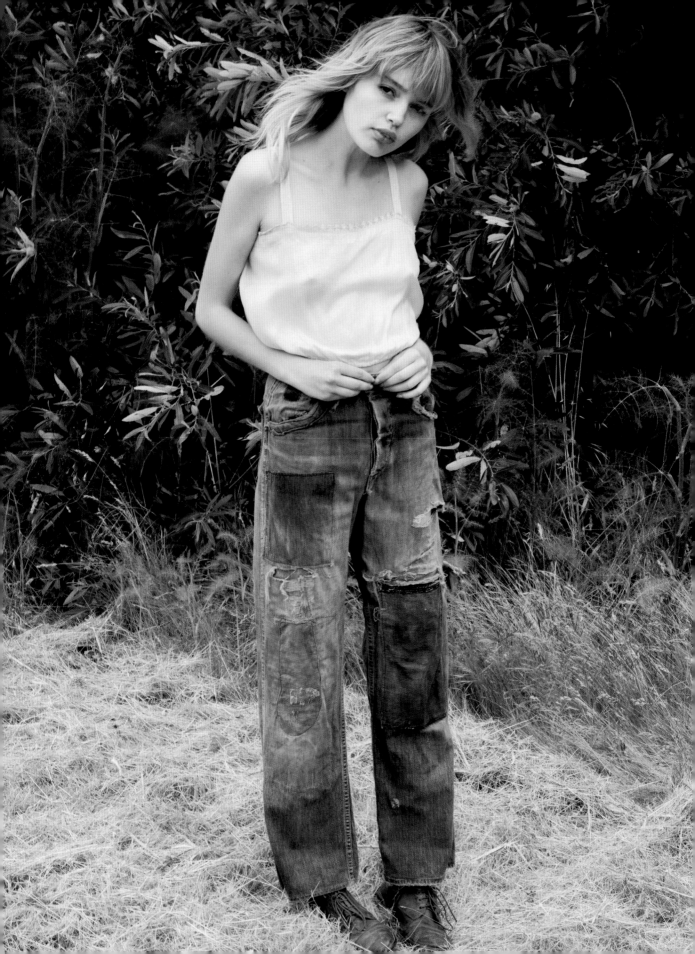

Girls

We appreciate the boldness & bravery of

women but cherish a girl's youthful dreaminess, unabashed hopefulness, gentle innocence and sweet discovery. Sometimes we spot it in an off moment—an impetuous leap in the air, a coy or reflective expression, or the way she wears her jeans high on her waist or low on her hips.

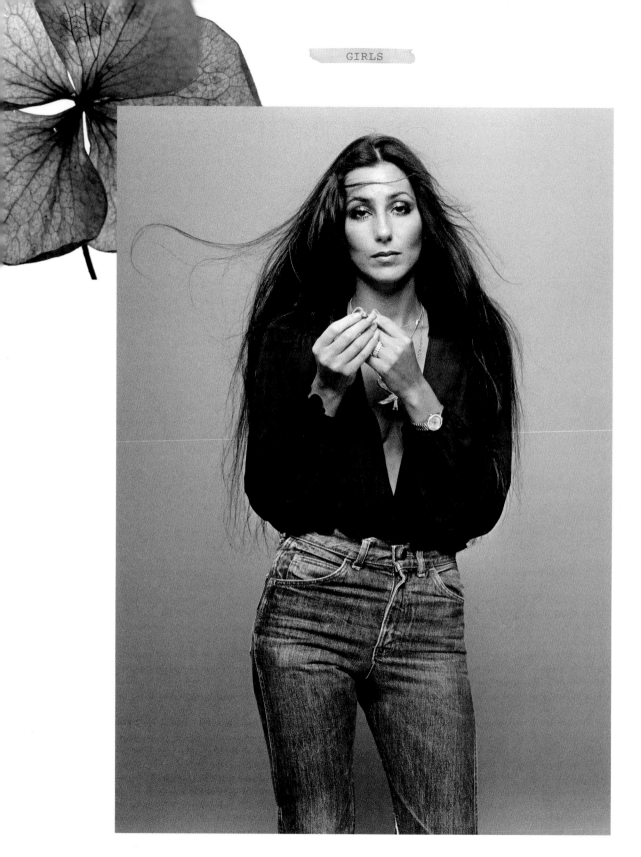

IN SHARP CONTRAST TO HER GLITTERING BOB MACKIE COSTUMES, CHER HERE EMERGES AS AN UNLIKELY
DENIM ICON AS SHE PARES DOWN HER LOOK. IT'S NOT EVEN JUST WHAT SHE IS WEARING BUT HOW SHE IS
WEARING IT—THE JEANS PULLED HIGH, THE NIPPED-IN WAIST, AND THE WAY THE DRAPEY SHIRT HANGS AND
FOLDS INTO HER JEANS.

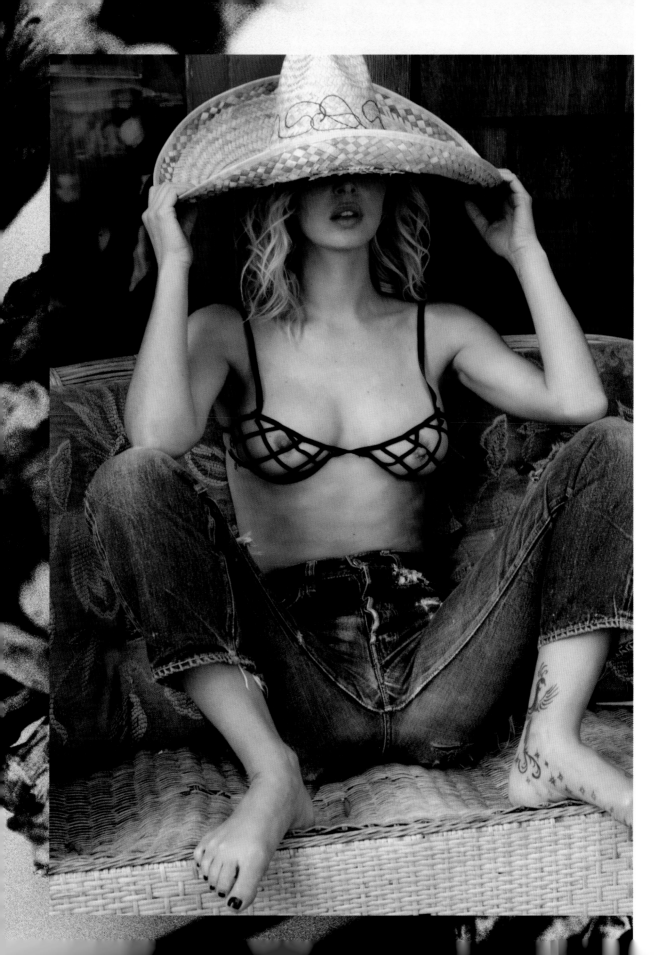

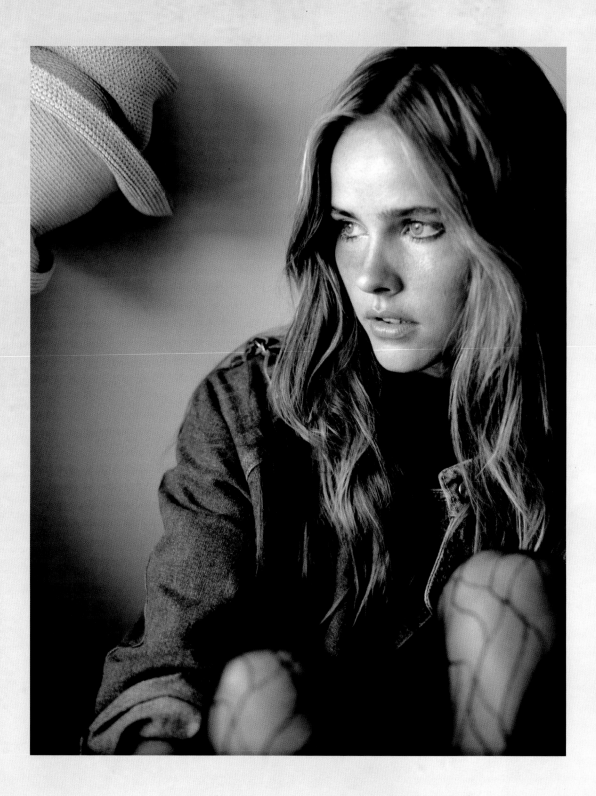

DREW BARRYMORE, SANTA MONICA, CA, 1991

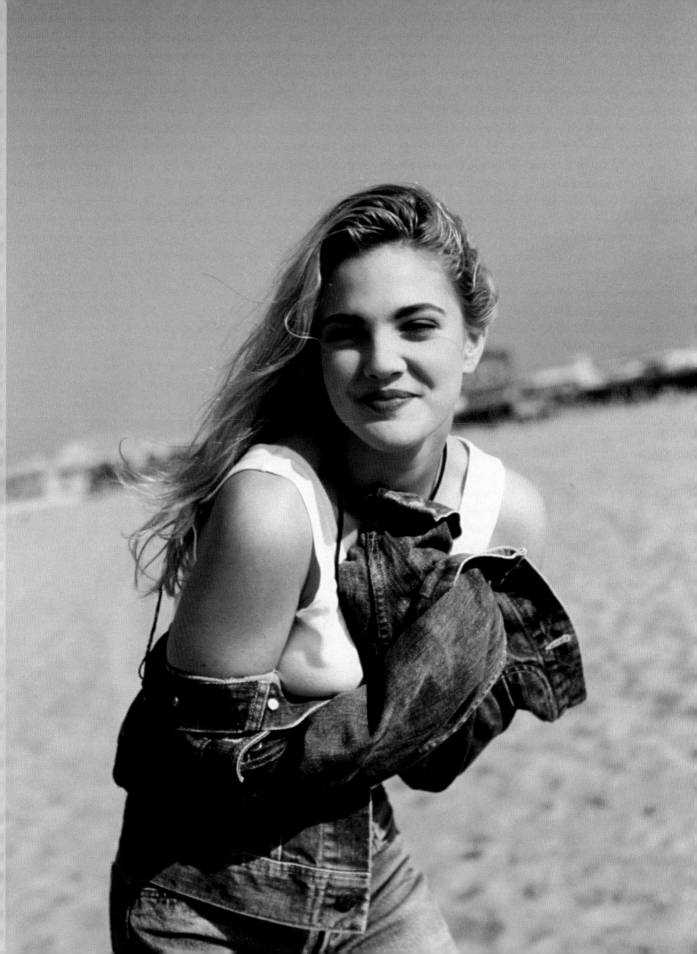

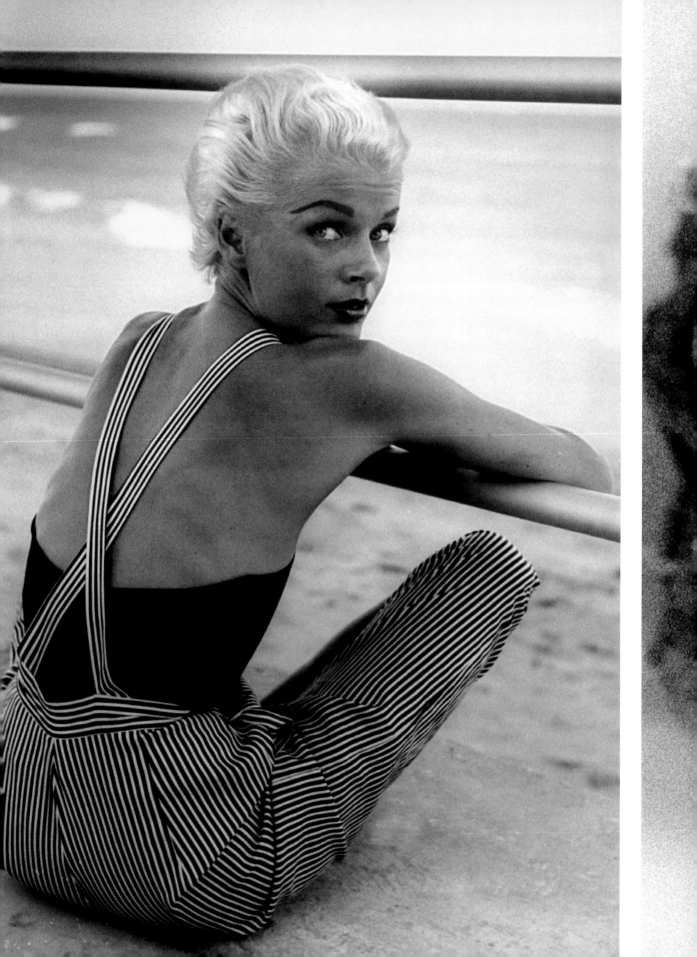

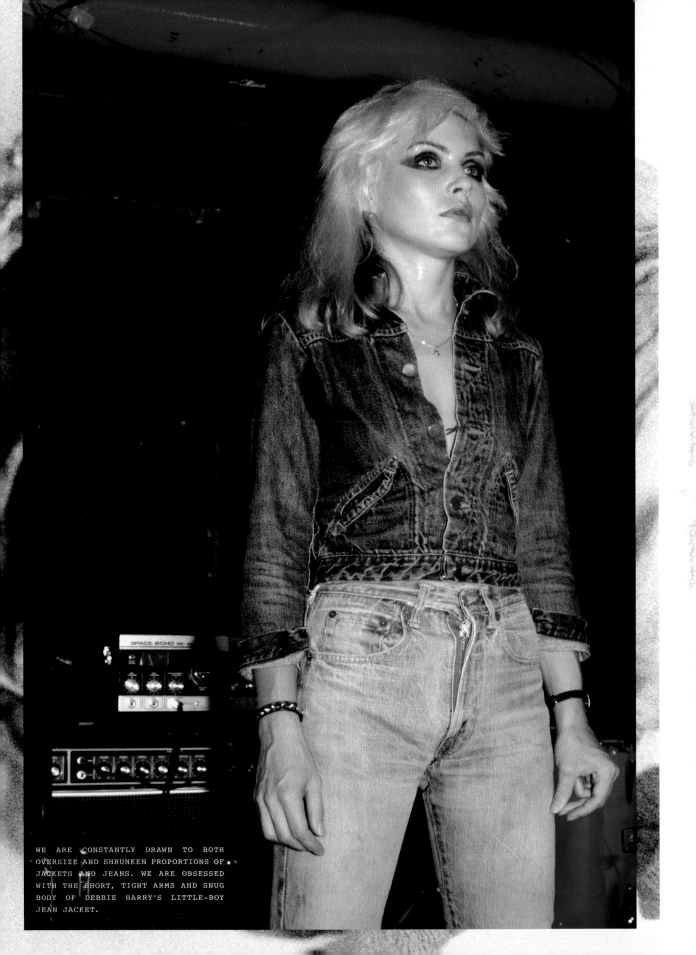

WE ARE CONSTANTLY DRAWN TO BOTH OVERSIZE AND SHRUNKEN PROPORTIONS OF JACKETS AND JEANS. WE ARE OBSESSED WITH THE SHORT, TIGHT ARMS AND SNUG BODY OF DEBBIE HARRY'S LITTLE-BOY JEAN JACKET.

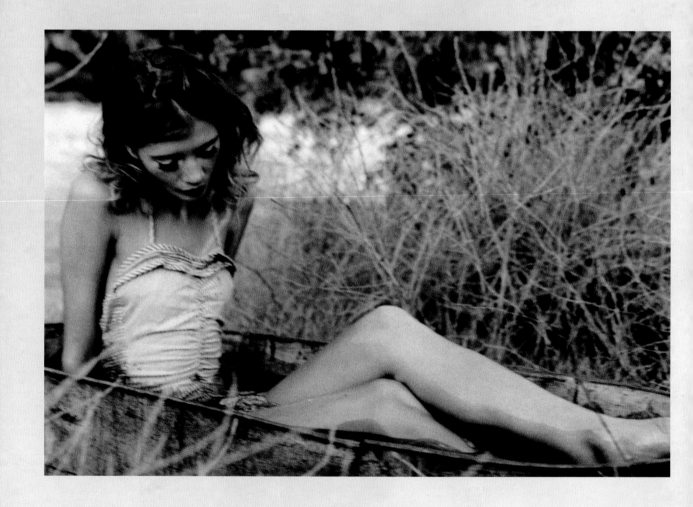

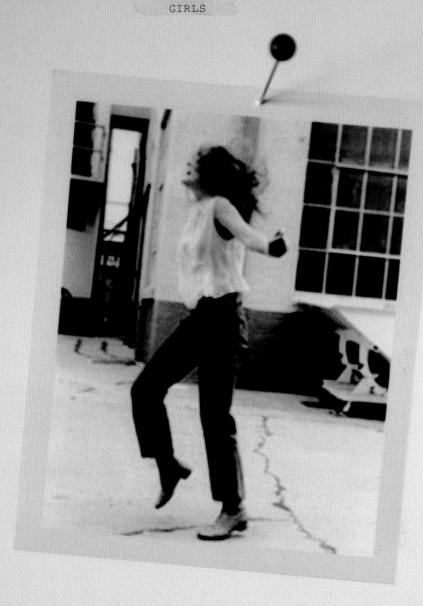

WHILE SHOOTING A FILM, ACTRESS LEIGH TAYLOR-YOUNG PERSONALLY CHOSE TO WEAR
JAMES DEAN'S JEANS FROM *REBEL WITHOUT A CAUSE* FROM THE WARNER BROTHERS' WARDROBE
DEPARTMENT. SHE MAKES THEM HER OWN WITH A FEMININE TOP AND FLAT BOOTS BUT
CLEARLY FEELS INSPIRED, FREE, AND, MOST CERTAINLY, A LITTLE REBELLIOUS.

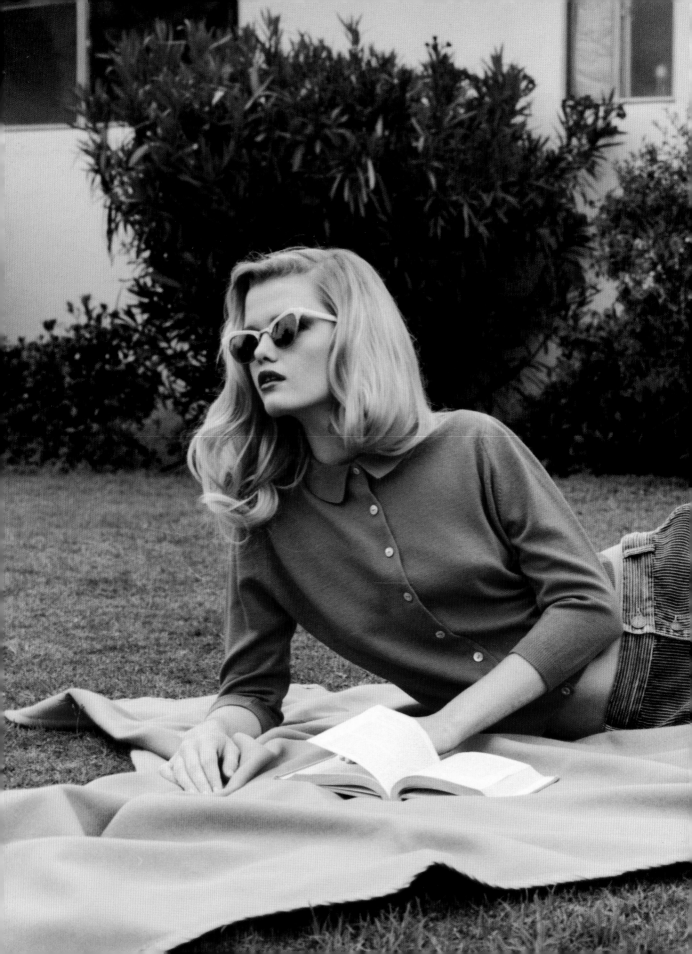

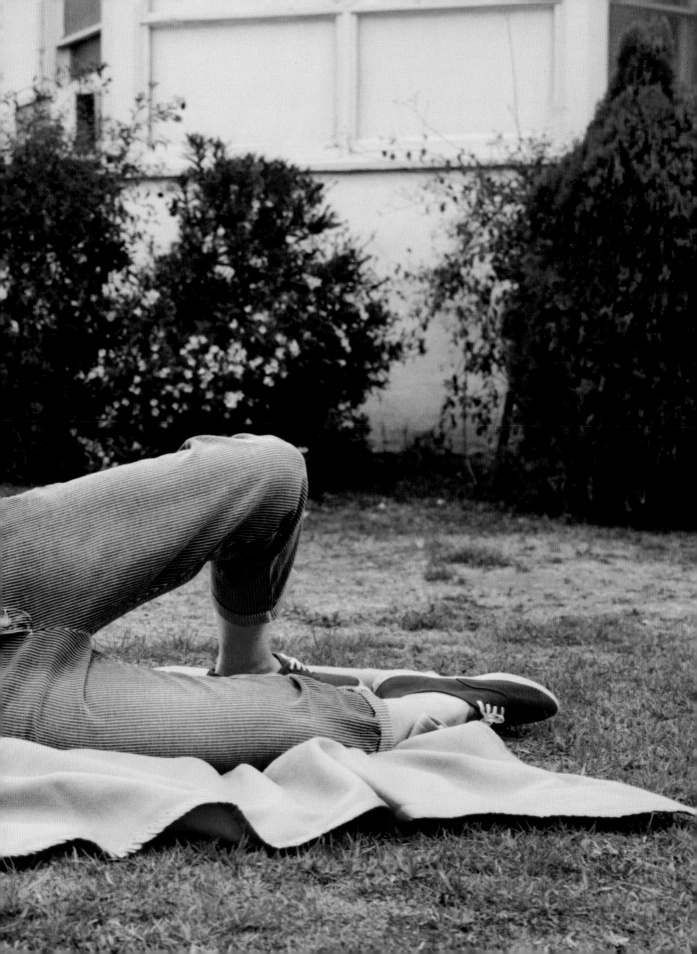

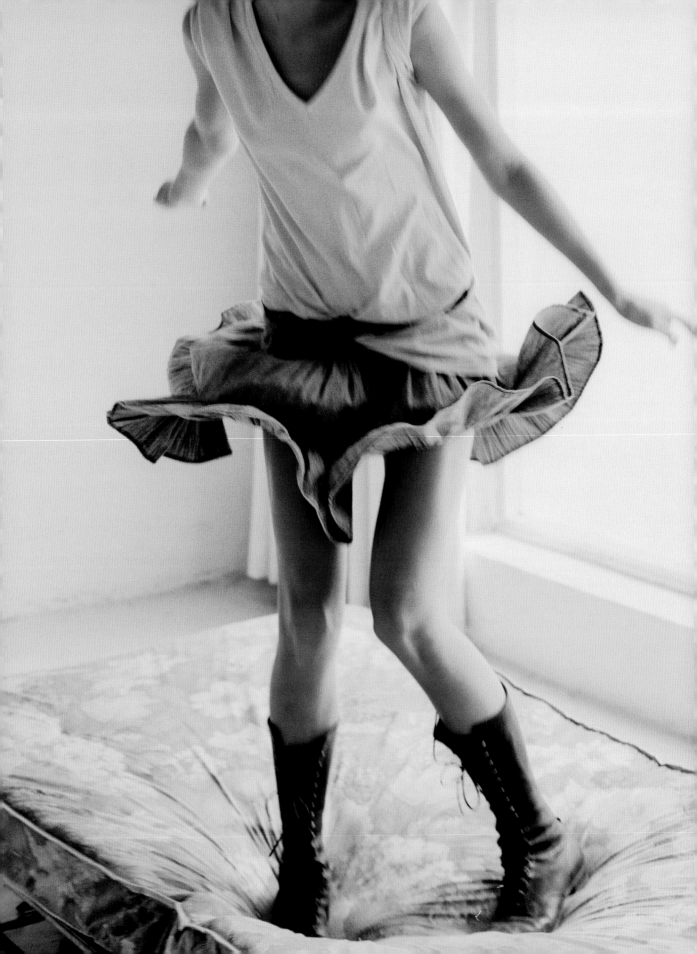

GIRLS HAVE A WAY OF TURNING A MUNDANE SITUATION INTO A SPONTANEOUS MOMENT OF EXHILARATION.

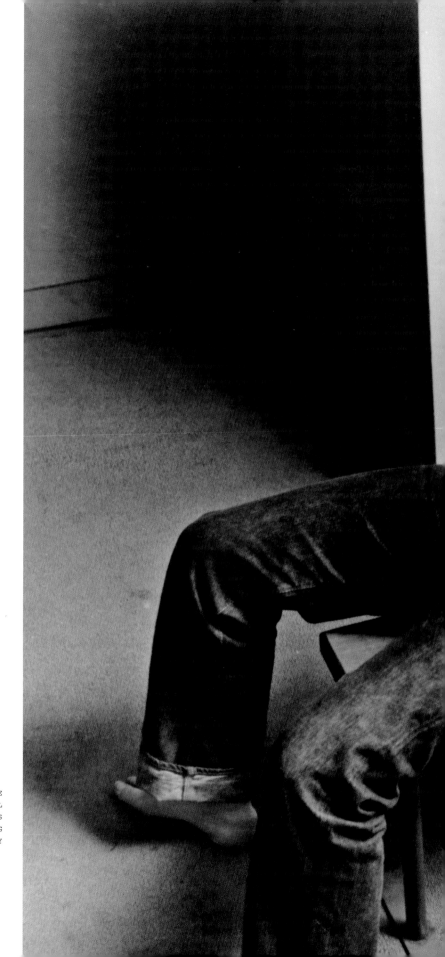

THIS IS ONE OF OUR ALL-TIME FAVORITE IMAGES. TO SEE MARILYN MONROE IN FULL HAIR AND MAKEUP WEARING MENS JEANS AND LIFTING BARBELLS, SHOWS THAT BEING STRONG AND BEAUTIFUL AREN'T MUTUALLY EXCLUSIVE BUT BEST PAIRED TOGETHER.

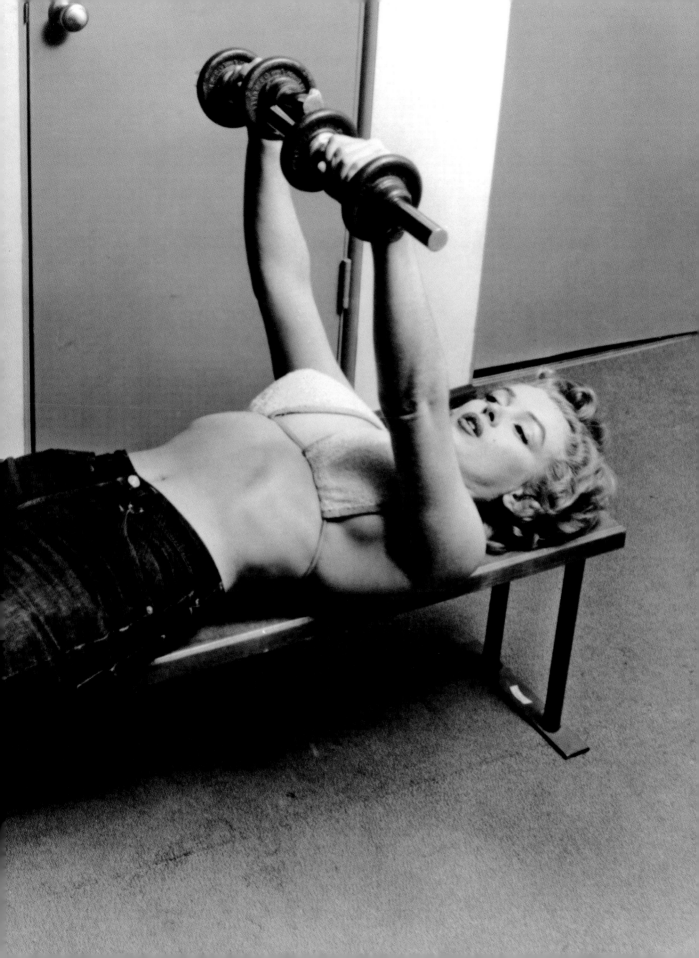

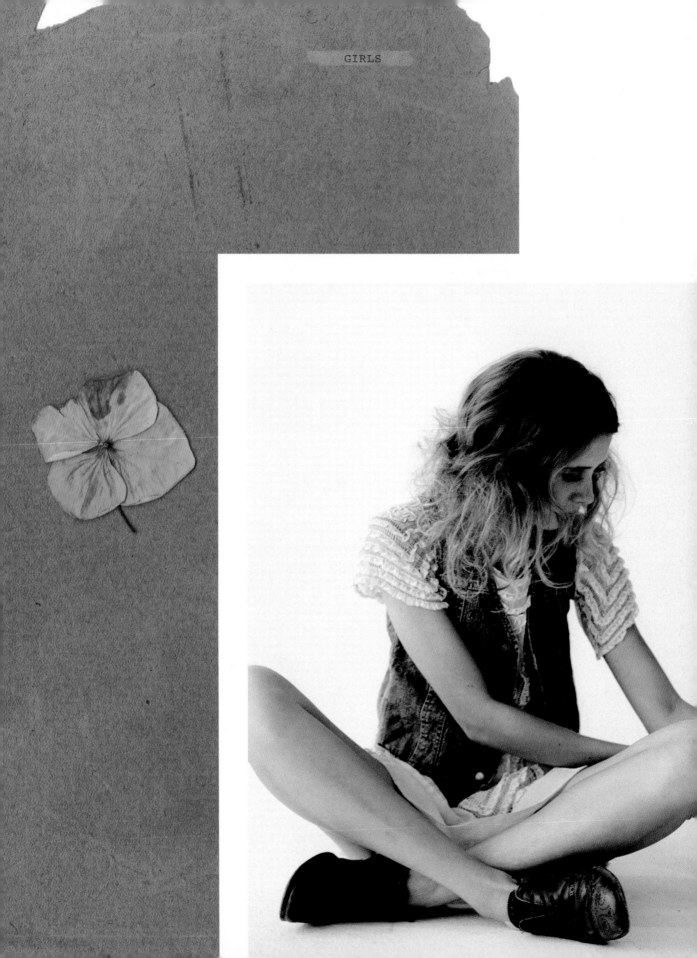

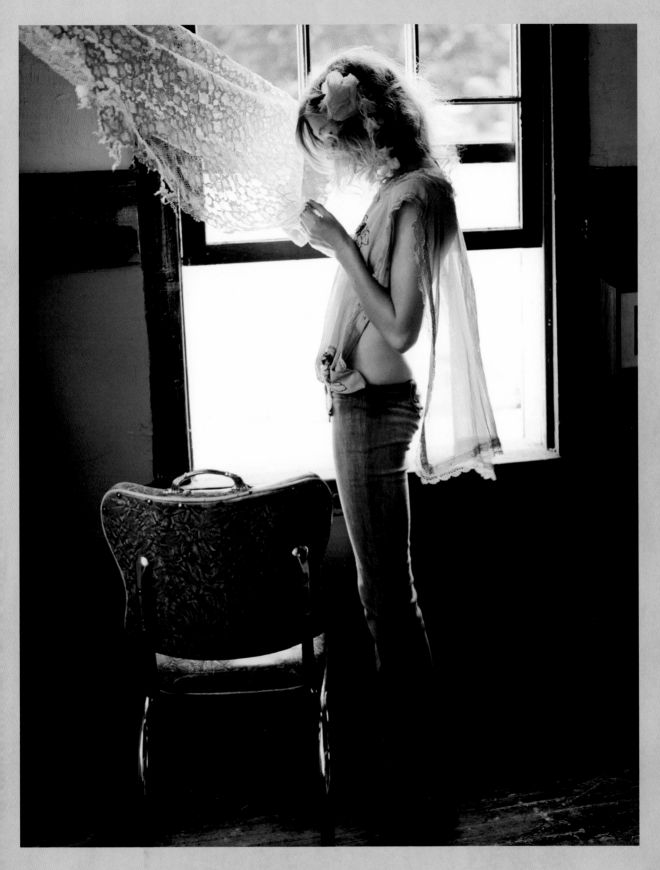

WE SEEM TO CONSISTENTLY PAIR THE TEXTURE OF RUGGED DENIM WITH MEN'S BROGUES AND SOFT
LACE OR RUFFLES TO ACHIEVE A CHARMING MASCULINE AND FEMININE DICHOTOMY.

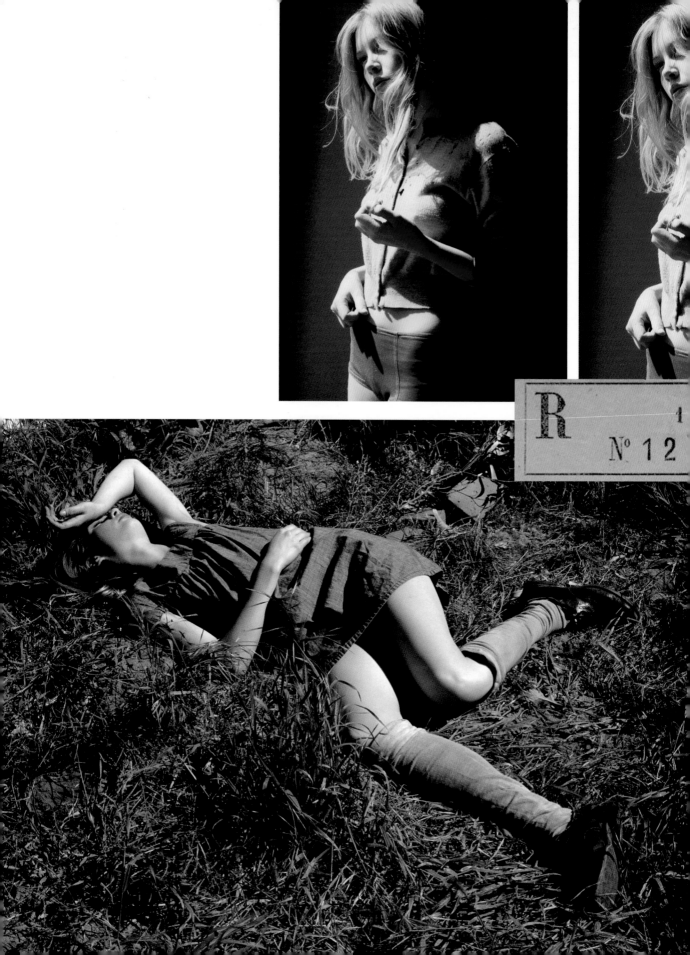

R 1
Nº 1 2

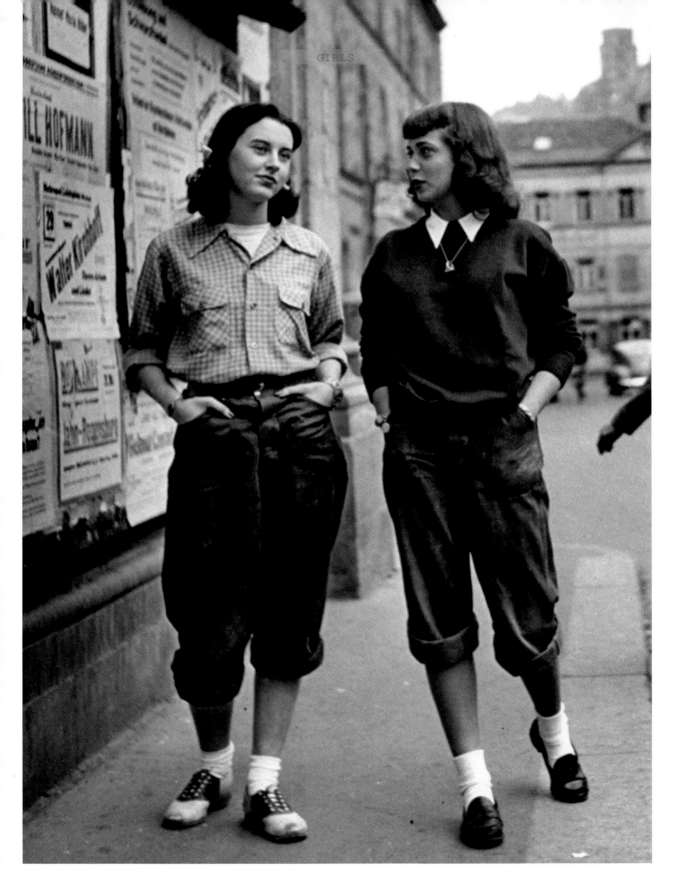

HIGH-LOW DRESSING HAS WEAVED ITS WAY THROUGH FASHION AND INTO OUR LIVES.
THESE TEDDY GIRLS TOOK TIME TO PERFECTLY CURL THEIR HAIR, BUT MINDLESSLY ROLL THEIR JEANS.

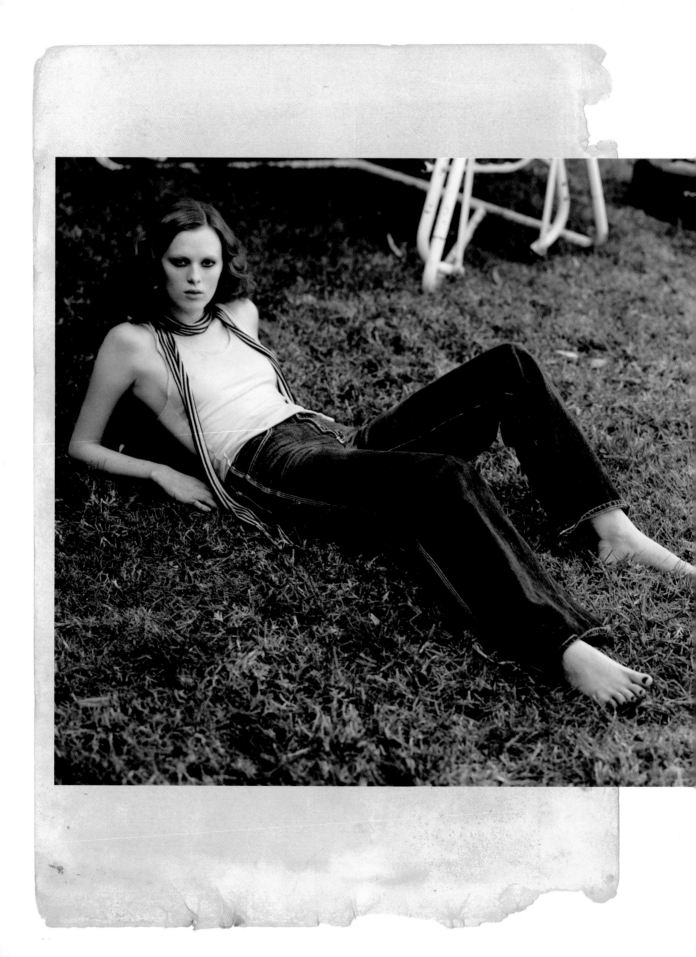

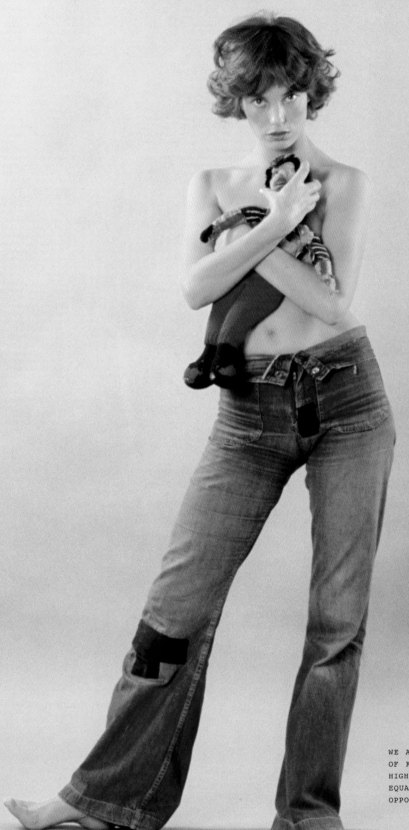

WE ARE ENCHANTED BY THE SIMILARITY
OF KAREN ELSON'S AND JANE BIRKIN'S
HIGH-WAISTED WIDE-LEG JEANS AND ARE
EQUALLY ENAMORED OF THEIR ABSOLUTE
OPPOSITE BODY LANGUAGE.

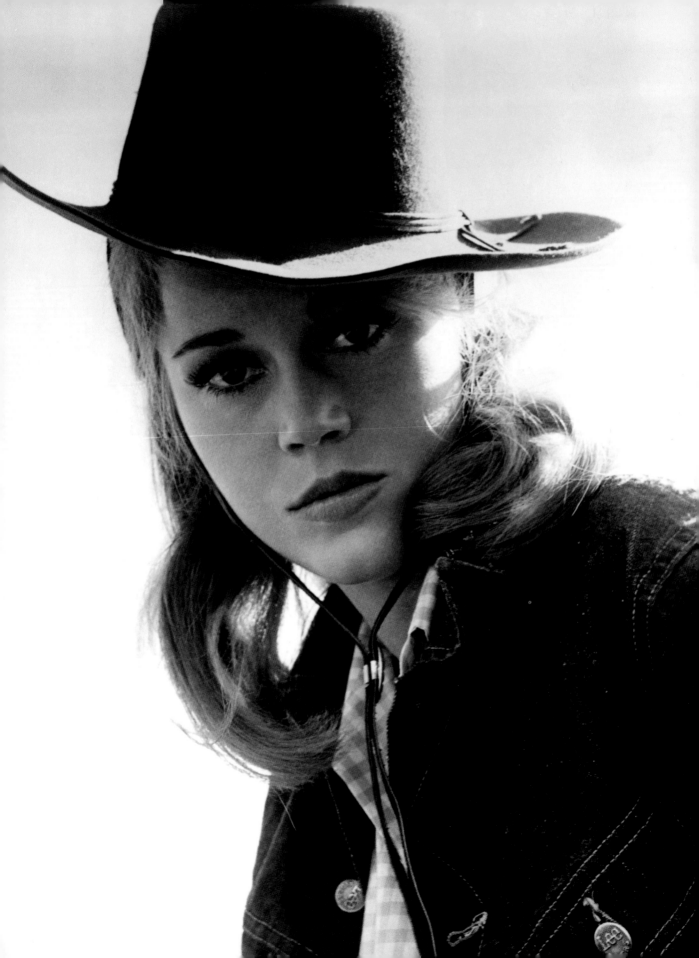

Home On the Range

We are endlessly inspired by the authenticity of work-wear on the farm. The true American spirit is captured in overalls surrounded by innocently sweet farm animals and dilapidated old fences. We are humbly reminded where denim originally came from, and we admire both its durability and function—grounding notions that transcend trends and eras alike.

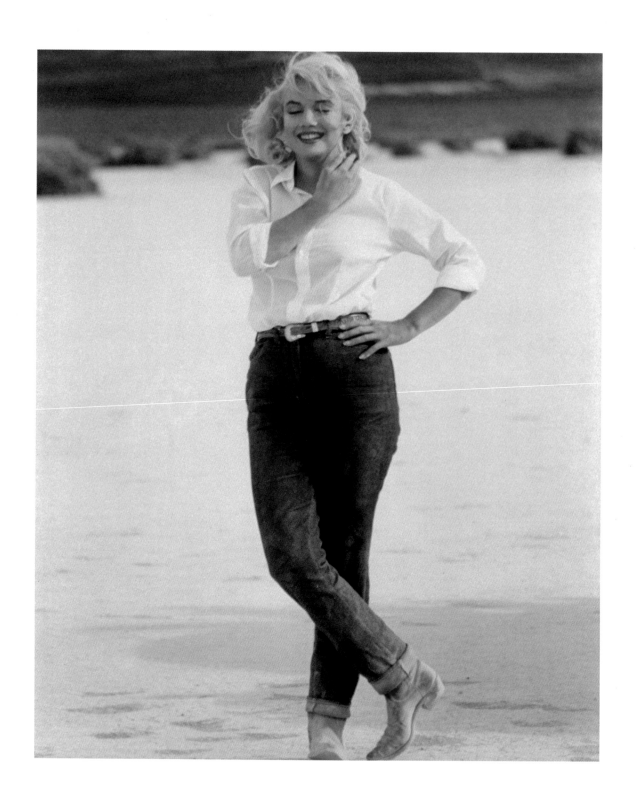

MARILYN CAPTURED IN COWBOY BOOTS-A RARE SIGHTING IN A BELOVED CLASSIC AMERICAN LOOK.

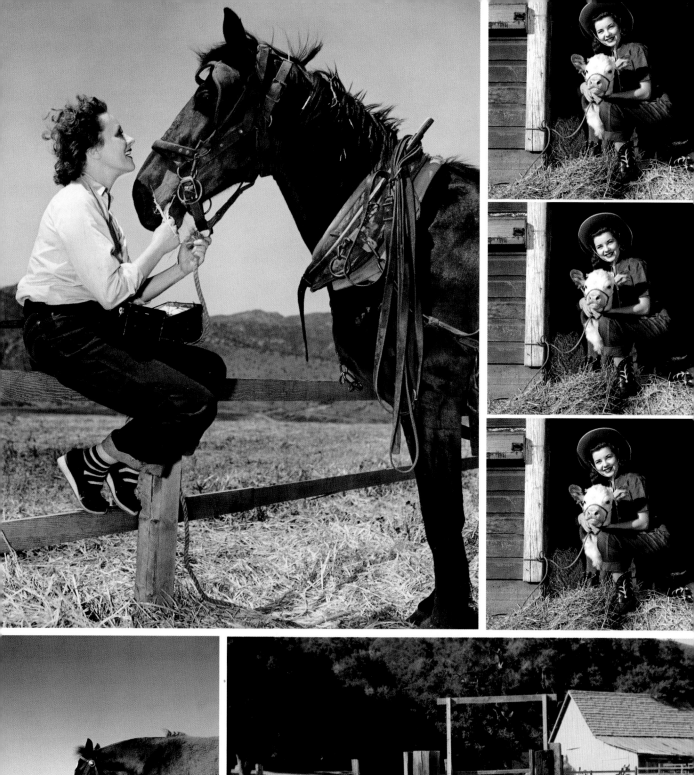
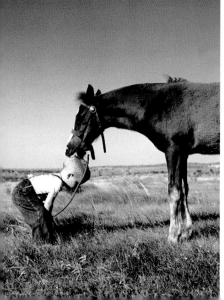
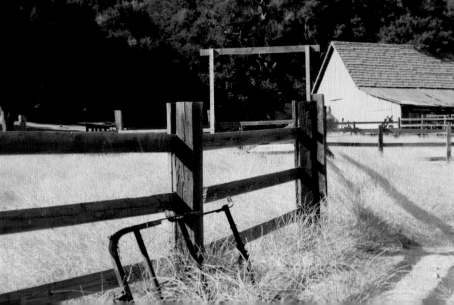

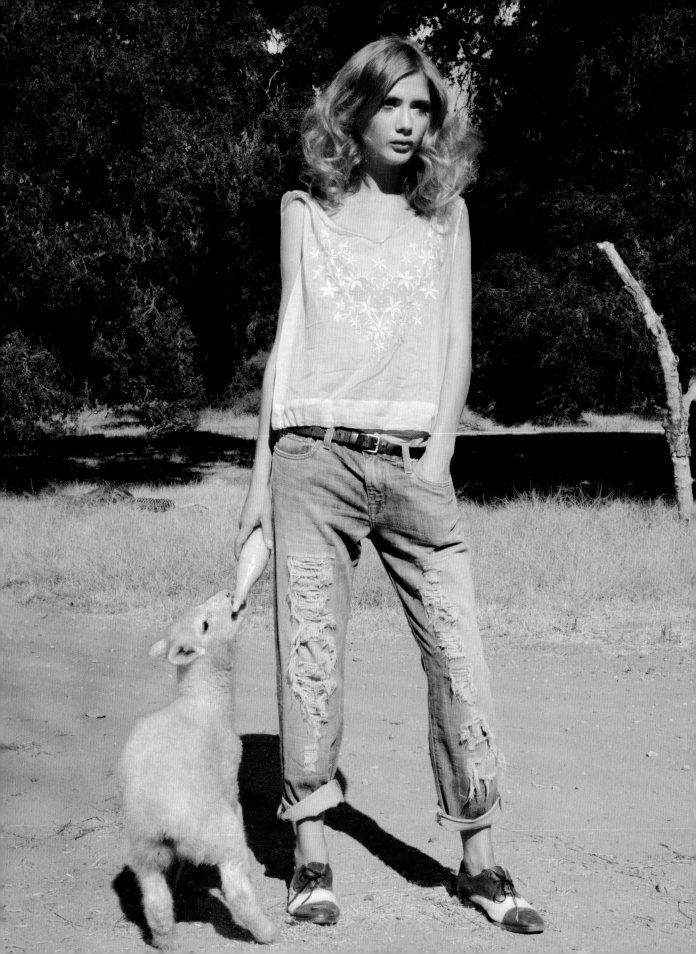

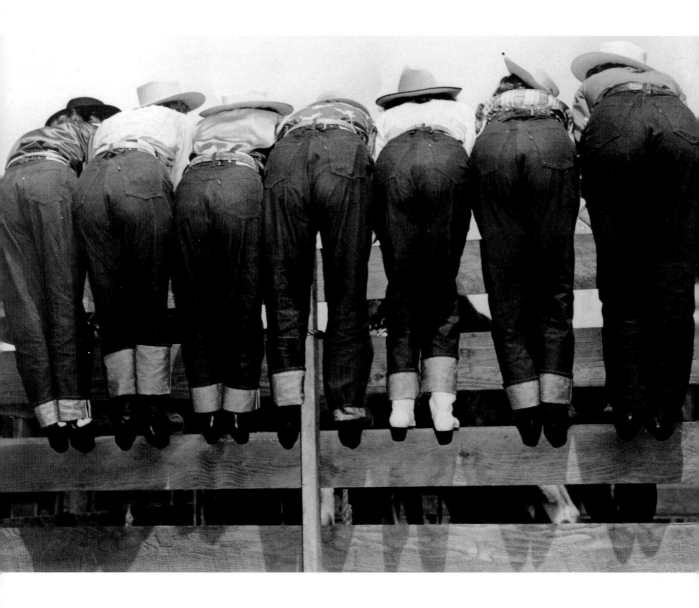

WORN DENIM LOOKS AND FEELS AT HOME ON A FARM—WHERE IT REMAINS AN ESSENTIAL
PART OF A FARMER'S (AND A GIRL FEEDING A FOUR-DAY-OLD LAMB) WARDROBE.

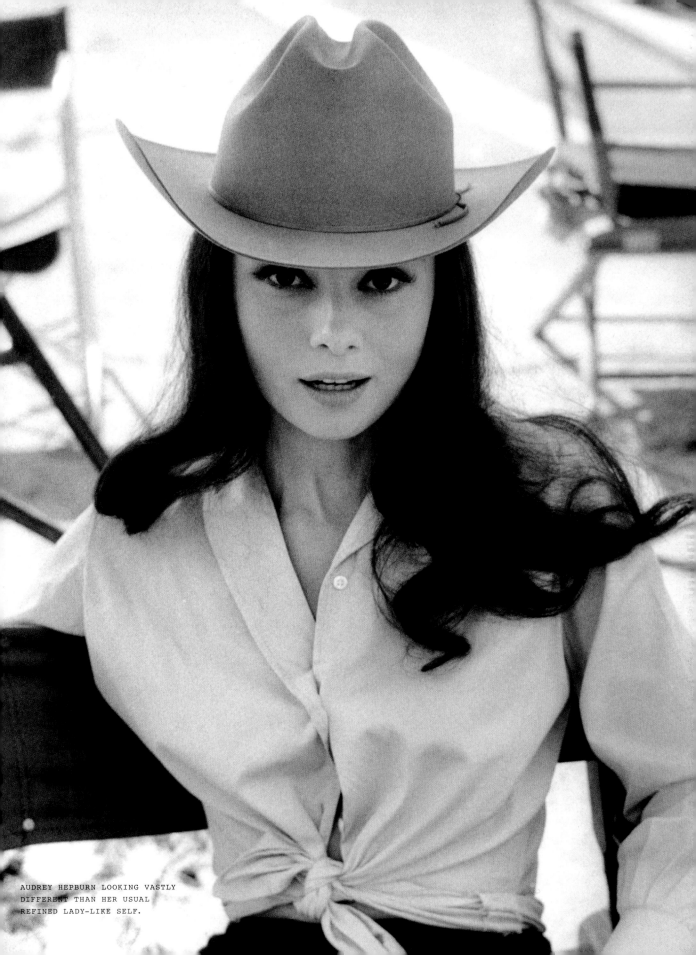

AUDREY HEPBURN LOOKING VASTLY
DIFFERENT THAN HER USUAL
REFINED LADY-LIKE SELF.

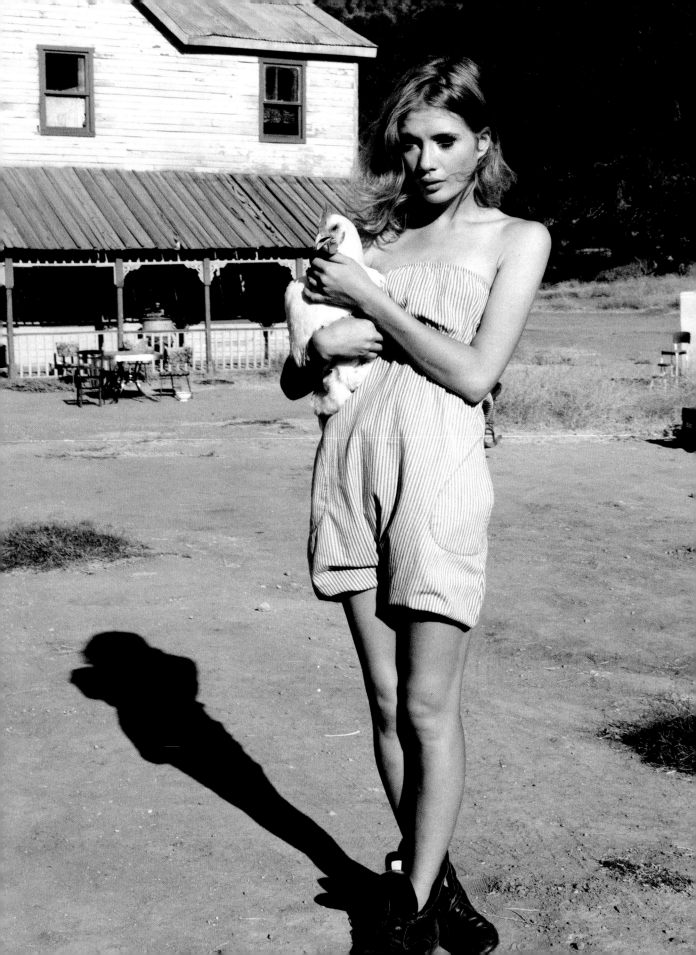

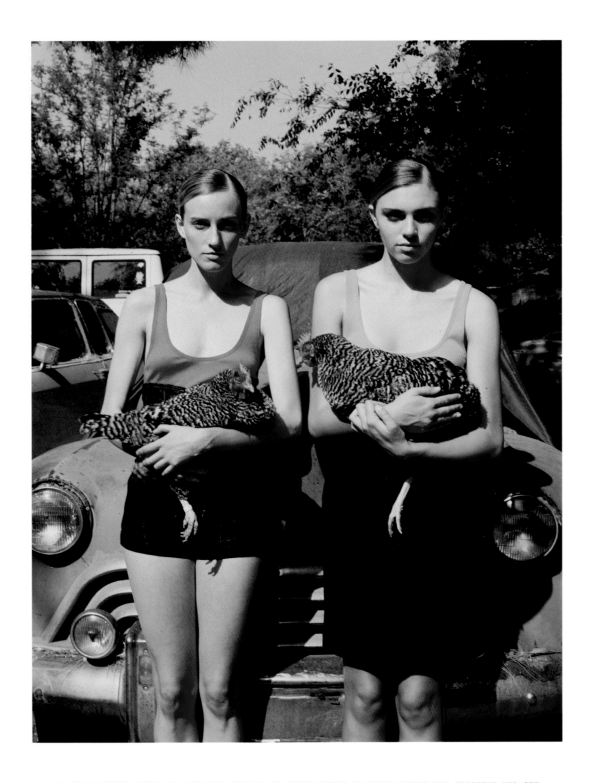

IT TOOK ALMOST HALF THE DAY FOR HILARY AND THESE GIRLS TO CATCH THOSE TWO CHICKENS AND GET
THEM TO RELAX FOR THE PHOTO. THEIR CRISP INDIGO DENIM FEELS APPROPRIATELY STOIC AND RIGID.

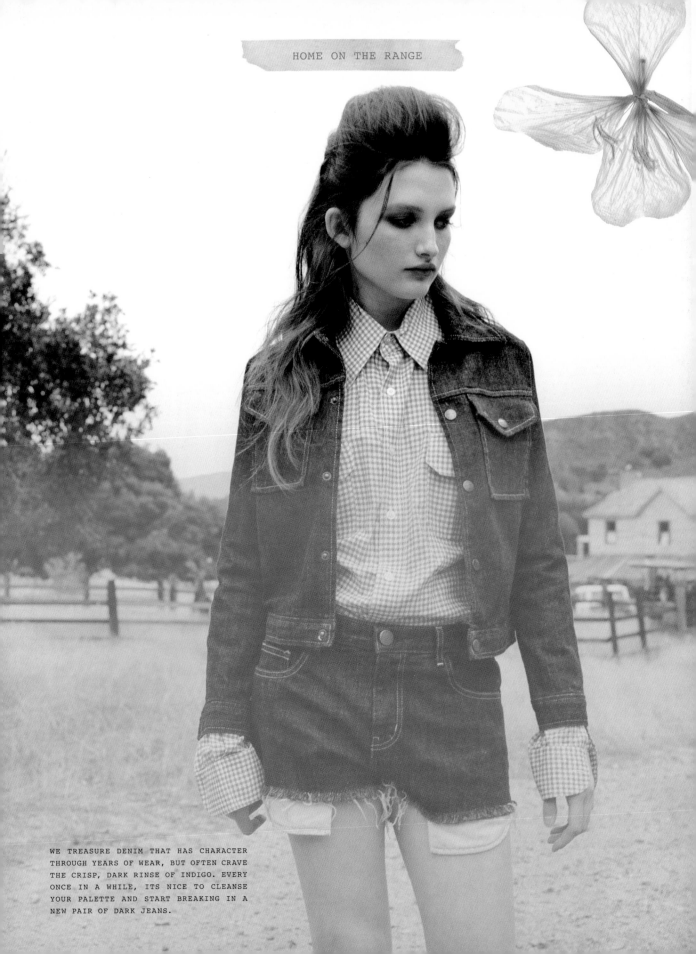

WE TREASURE DENIM THAT HAS CHARACTER
THROUGH YEARS OF WEAR, BUT OFTEN CRAVE
THE CRISP, DARK RINSE OF INDIGO. EVERY
ONCE IN A WHILE, ITS NICE TO CLEANSE
YOUR PALETTE AND START BREAKING IN A
NEW PAIR OF DARK JEANS.

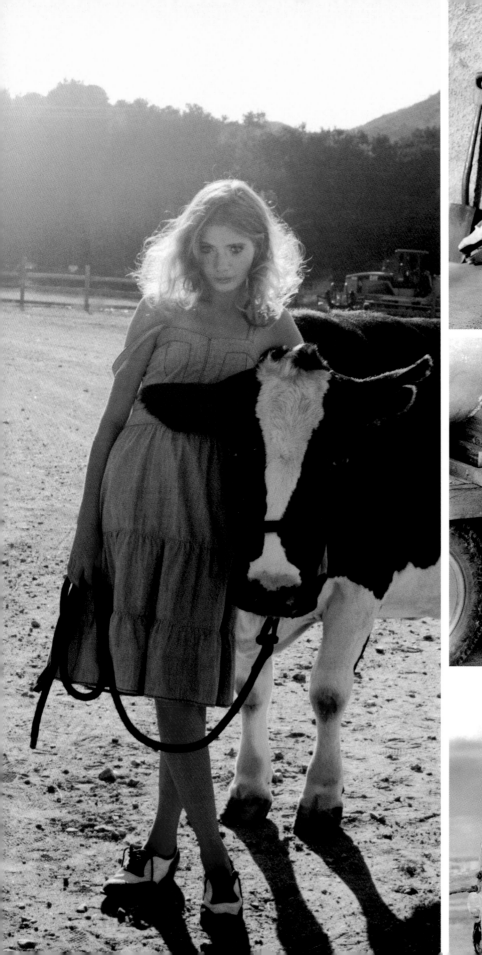
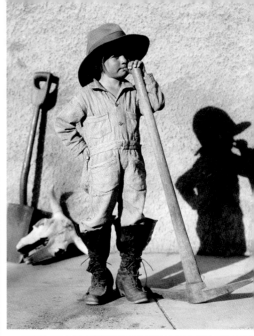

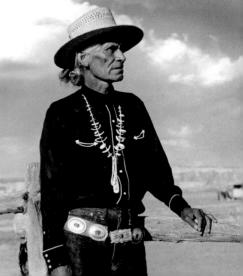

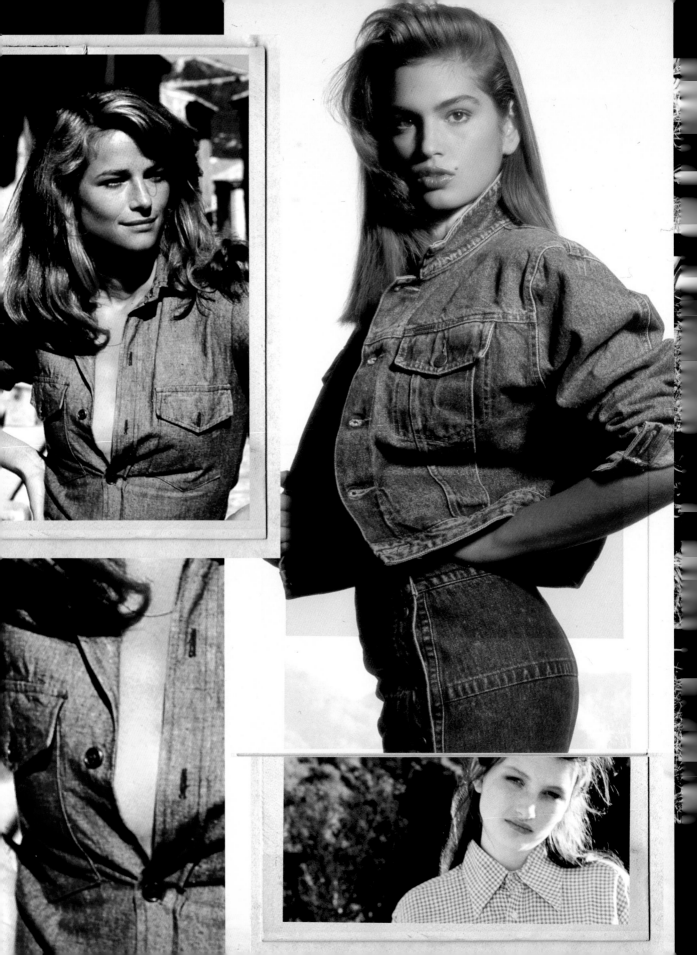

collars; Collars

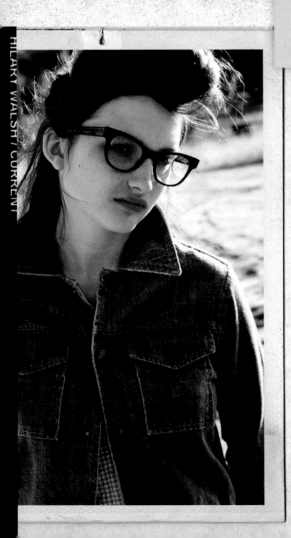

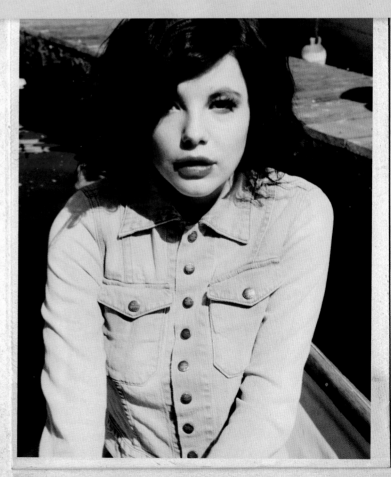

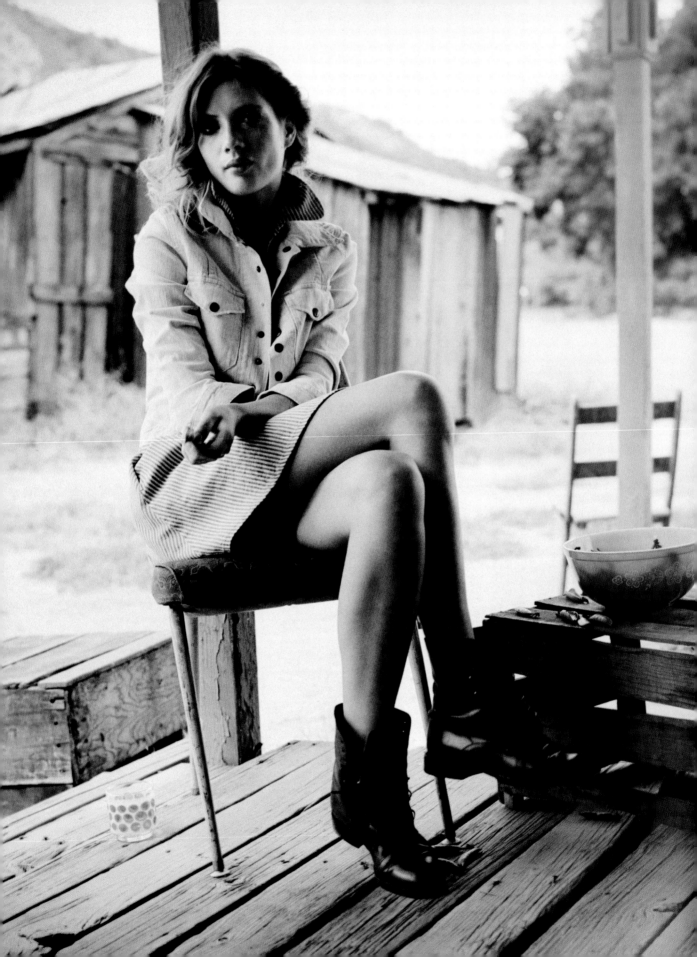

On the Porch

To us, porches symbolize the ease of an American family on a warm summer night, relaxing with amber-colored iced teas on a passed-down rocking chair, making a quilt full of layers, and life. They are symbolic of a chat with an old friend or just a quiet moment waiting for someone, thinking of someone, becoming someone. Much like an old pair of jeans, we love how a wooden porch gets better with time—growing deliciously rich with character while holding on to our secrets and stories with care.

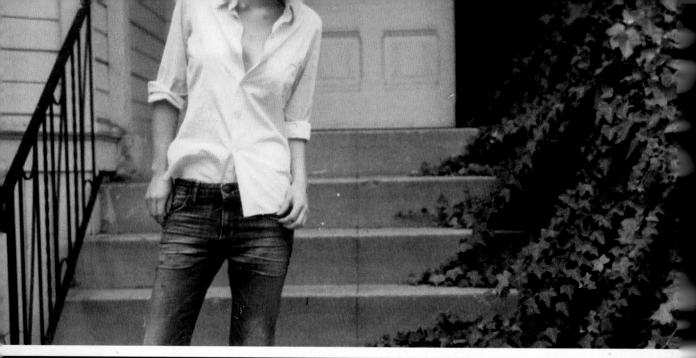

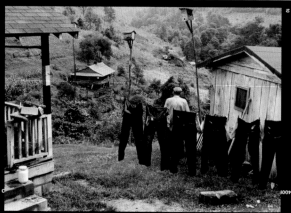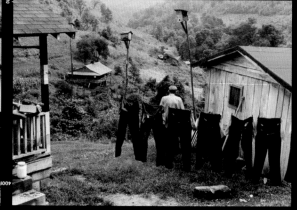

HILARY WALSH / CURRENT

ELLIOT 14582-63

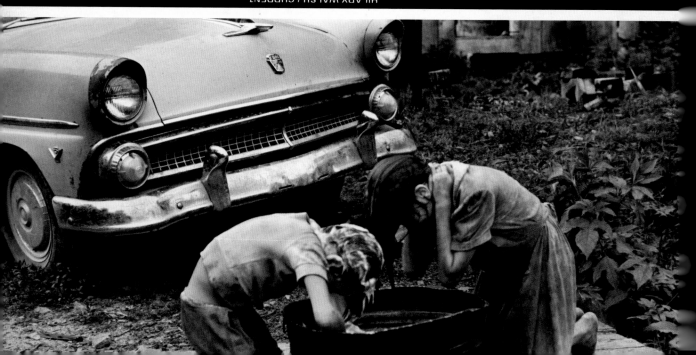

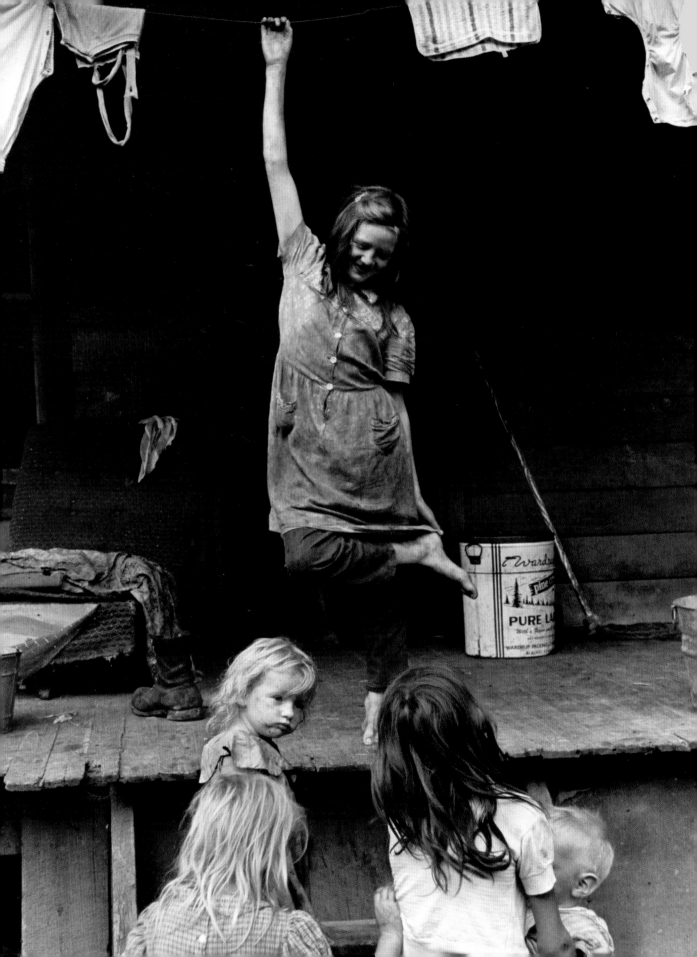

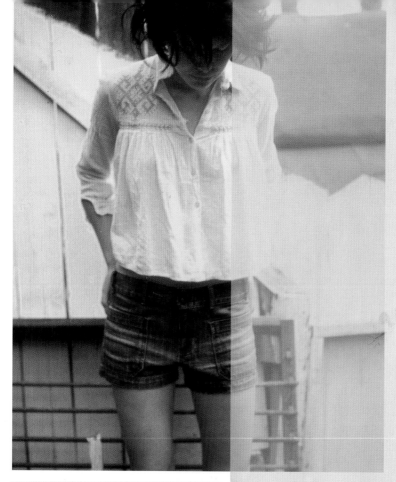

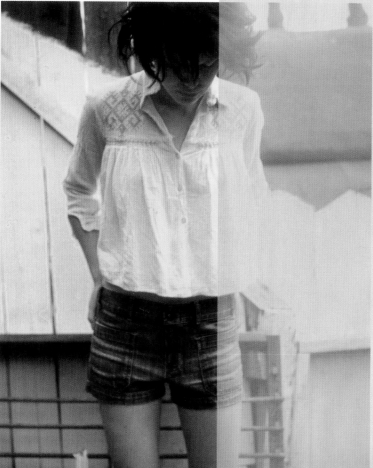

WHILE A GREAT DENIM MOMENT HAS MUCH TO DO WITH MANY ELEMENTS COMING TOGETHER, WHAT MAKES ONE ESPECIALLY CAPTIVATING IS WHEN A GIRL IS FEELING MOST COMFORTABLE AND AT HOME IN HER JEANS.

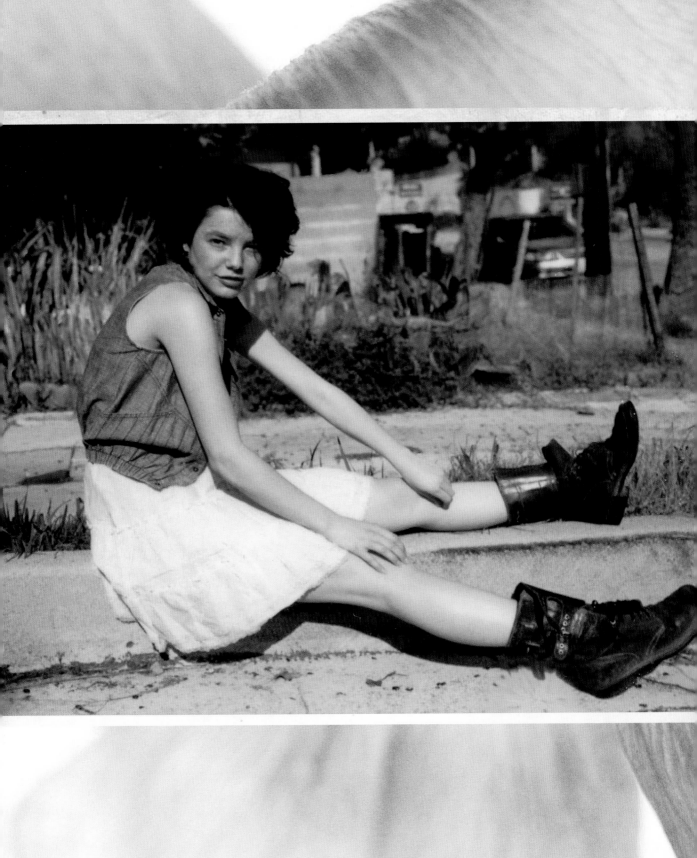

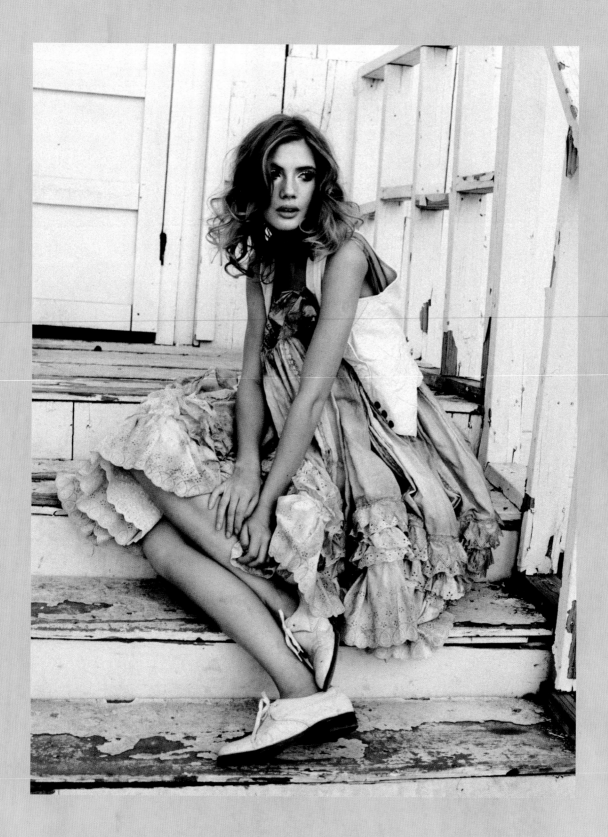

THE WEATHERED PATINA OF AN AGED PORCH MIRRORS THE DESTRUCTION AND FRAY OF WELL LOVED DENIM.

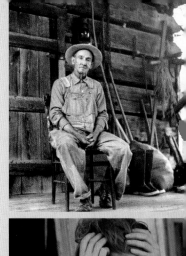

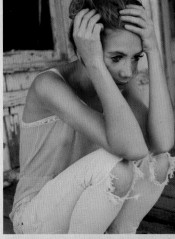

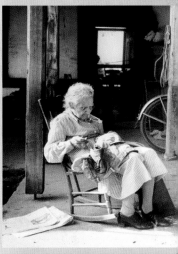

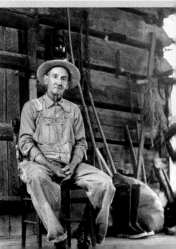

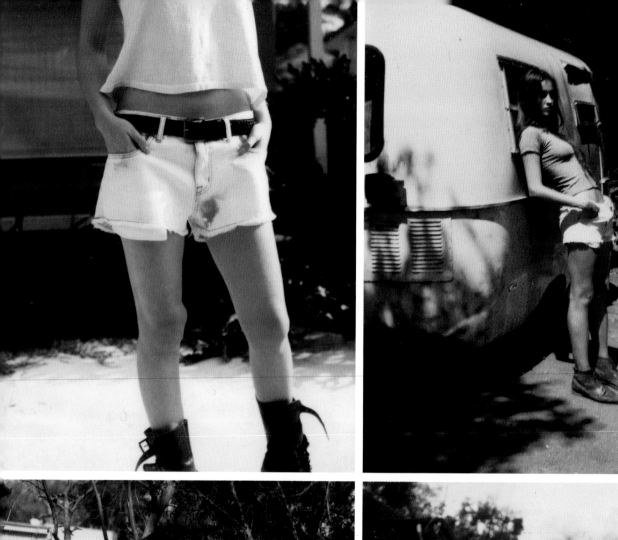
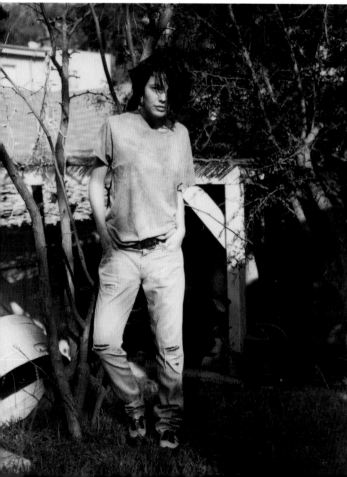
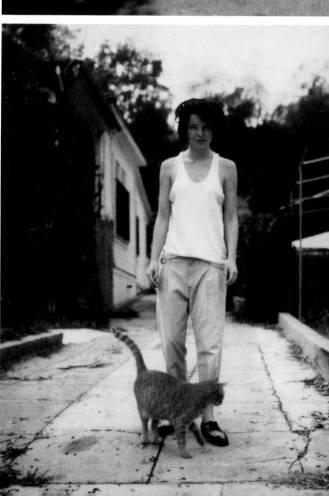

Out in the Trailer

The idea of life in a trailer recalls a feeling of adventure and resourcefulness. Much like our childhood favorite, the *Boxcar Children* novels, we envision a life of fantasy in a forest, where dressing up and daydreaming feel indulgently youthful and entirely magical. We enjoy the challenge of making the best of something with limited resources- from finding treasures in thrift stores to mending a torn knee with a found needle and thread.

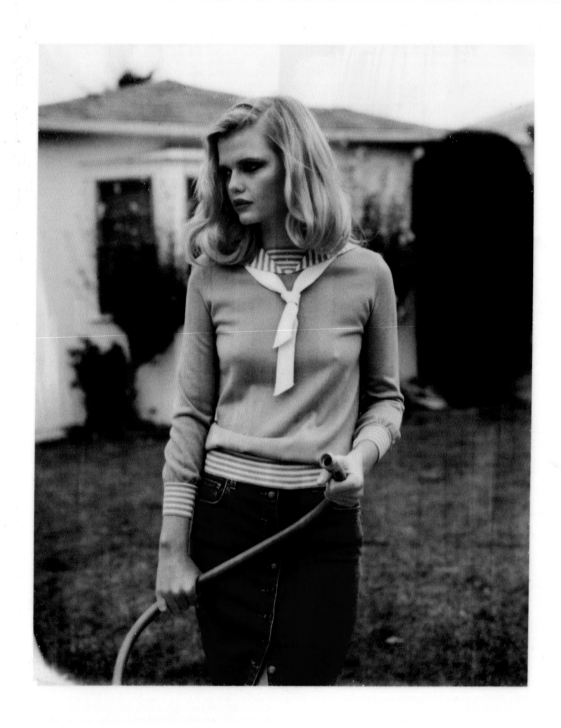

WE ARE ENTRANCED WITH THE BLUE OF DENIM THAT CAN TAKE ON AN ALMOST INTENTIONALLY
VIBRANT HUE IN A MUNDANE, QUIET ENVIRONMENT OF THE SIMPLE LIFE.

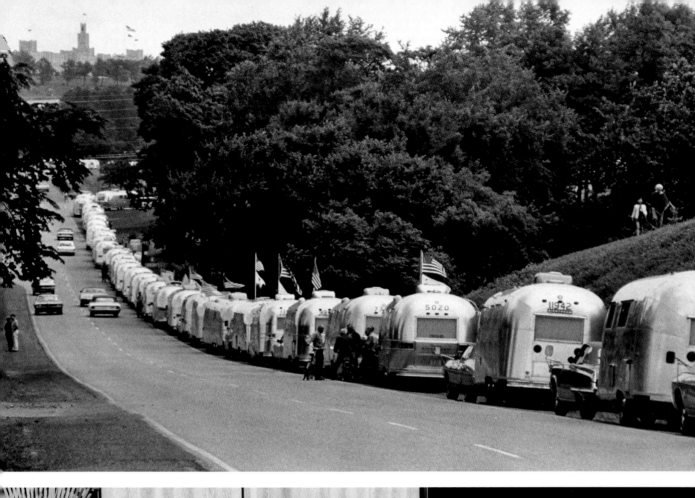

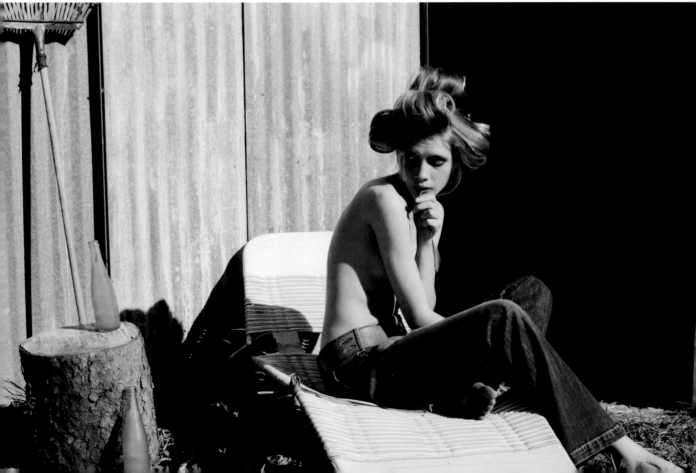

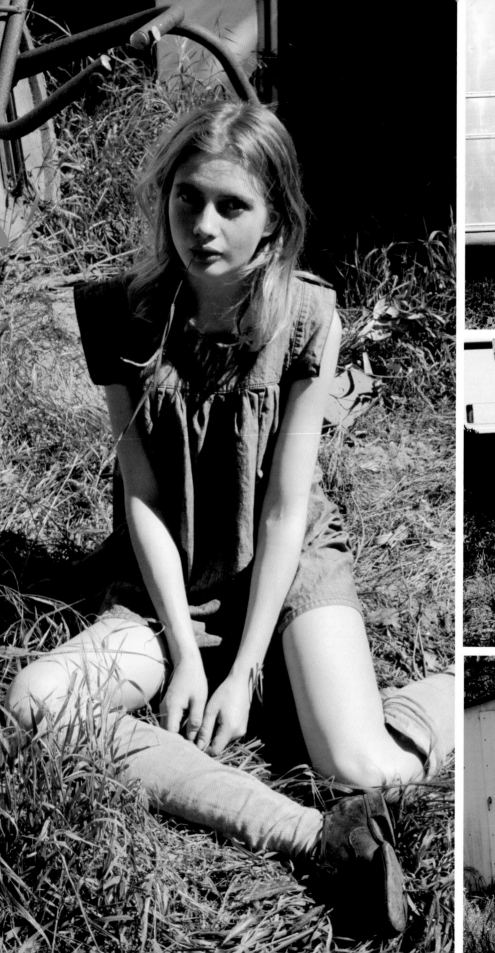
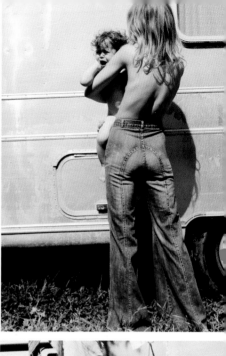
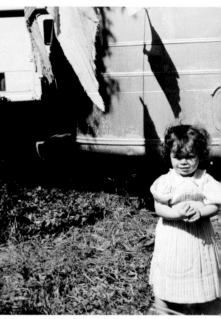
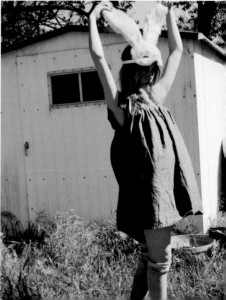

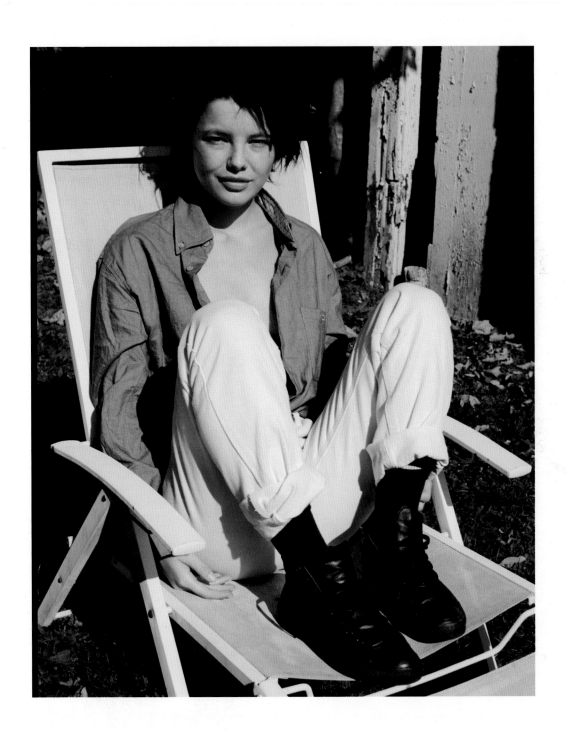

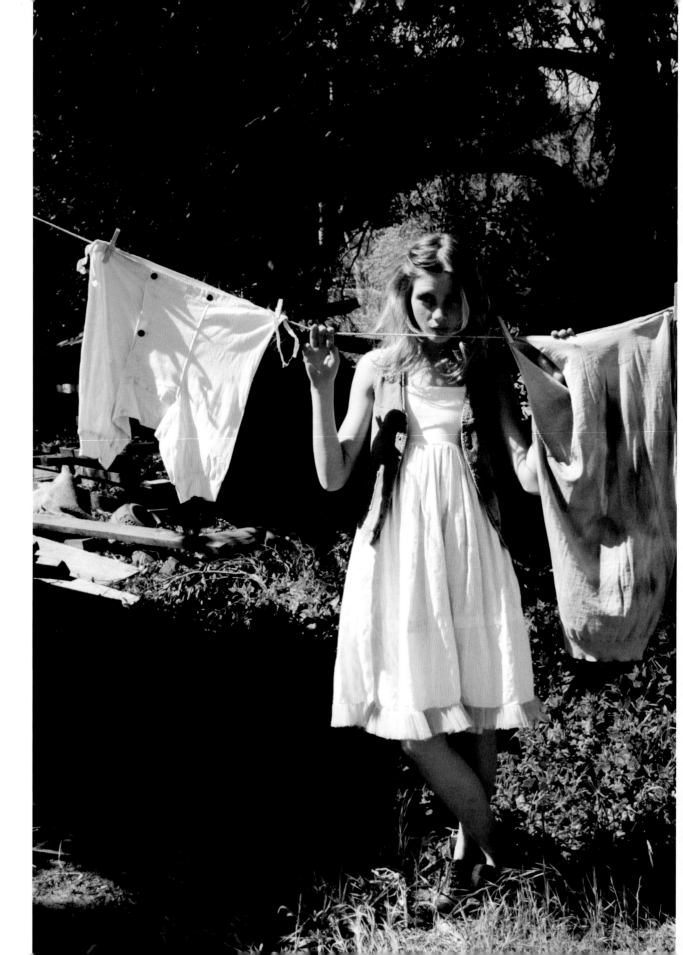

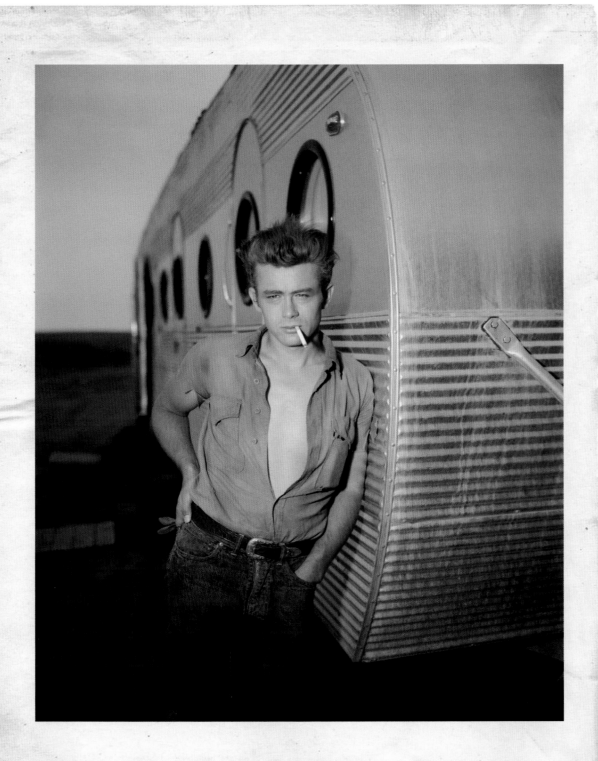

JAMES DEAN, THE ULTIMATE DENIM ICON, LEANING AGAINST A TRAILER,
IN A MOMENT OF SUPREME COOLNESS.

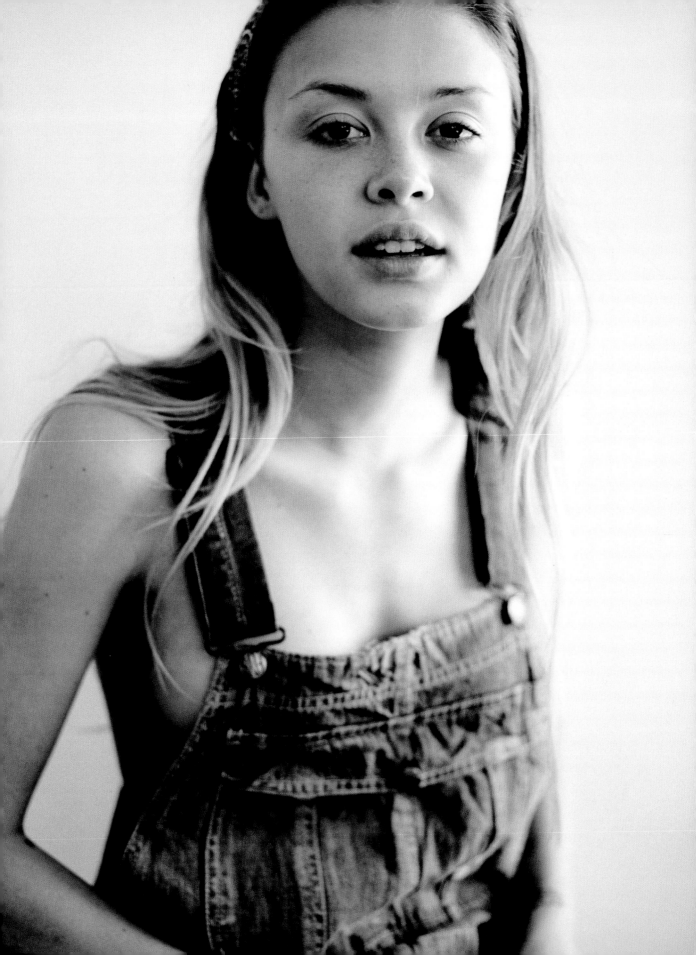

Overalls

Overalls have come a long way since first introduced in 1750 as protective work-wear garb. They are an all-American uniform that feel uniquely ageless, genderless, and timeless. It's a marvel to watch how a pair of denim overalls can make a farmer look rugged, a woman seem playful, and a child feel precious.

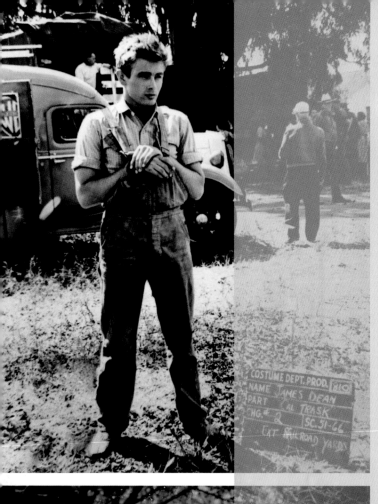

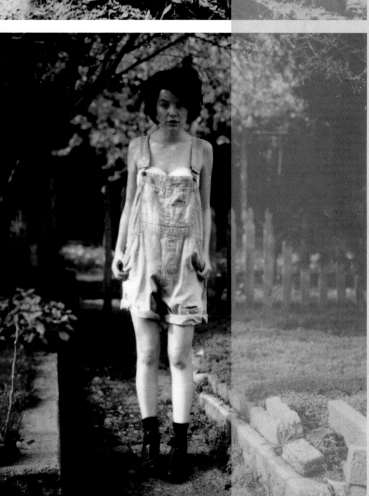

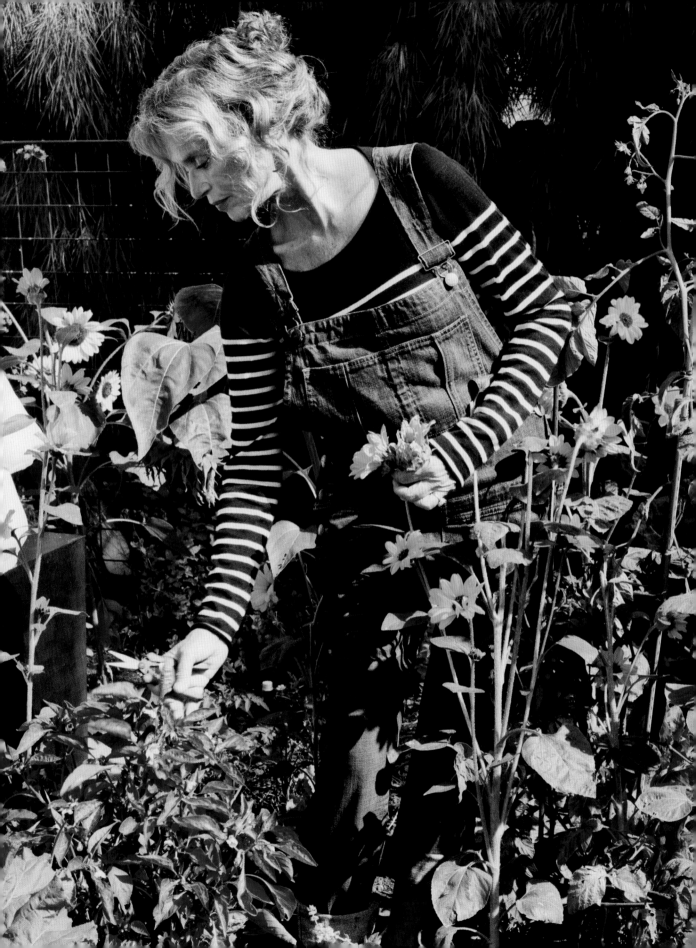

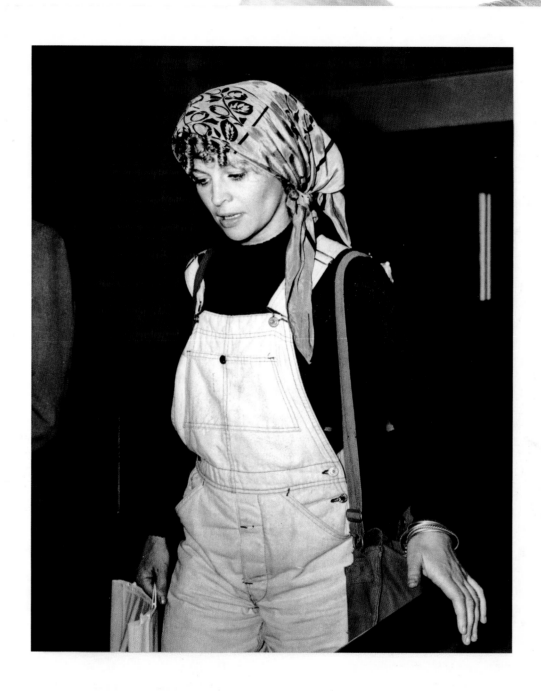

OVERALLS HAVE CHANGED IN SHAPE AND STYLING THROUGH THE YEARS, BUT REMAIN AT THEIR
MOST ENDEARING WHEN OVERSIZED AND WORN IN. FINDING A VINTAGE PAIR THAT IS STAINED FROM
OIL AND MENDED FROM A ROUGH DAYS WORK IS EXHILARATING.

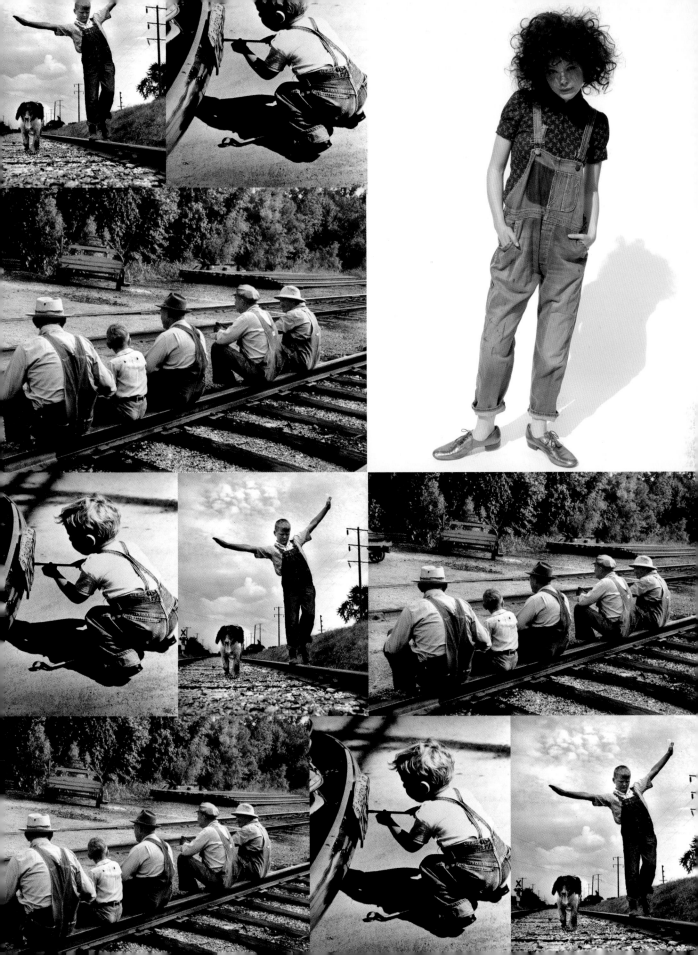

IT'S AMAZING HOW SIMPLY PUTTING ON A PAIR OF OVERALLS CAN MAKE A GROWN-UP FEEL PLAYFUL AND UNINHIBITED.

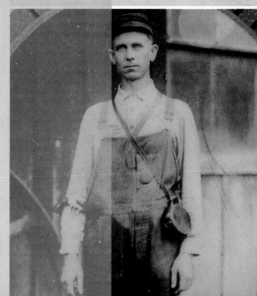

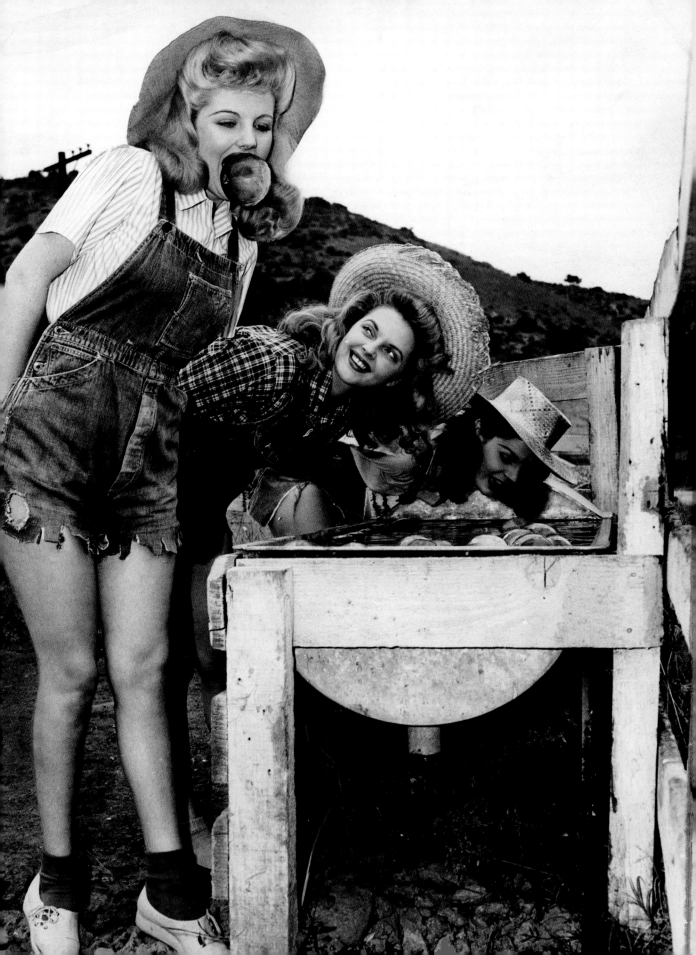

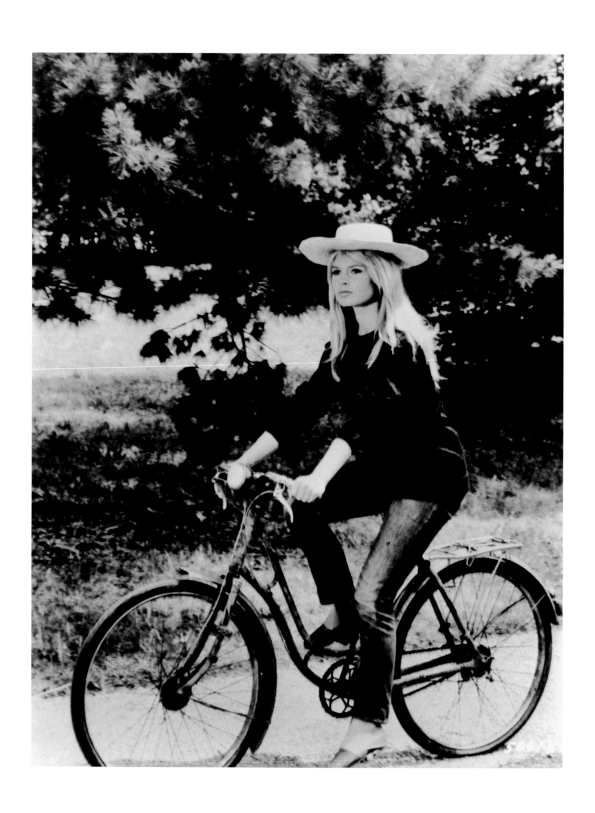

the Rambler

"So baby let's sell your diamond ring.
Buy some boots and faded jeans and go away.
This coat and tie is choking me . . . "

−Waylon Jennings
Luckenbach, Texas

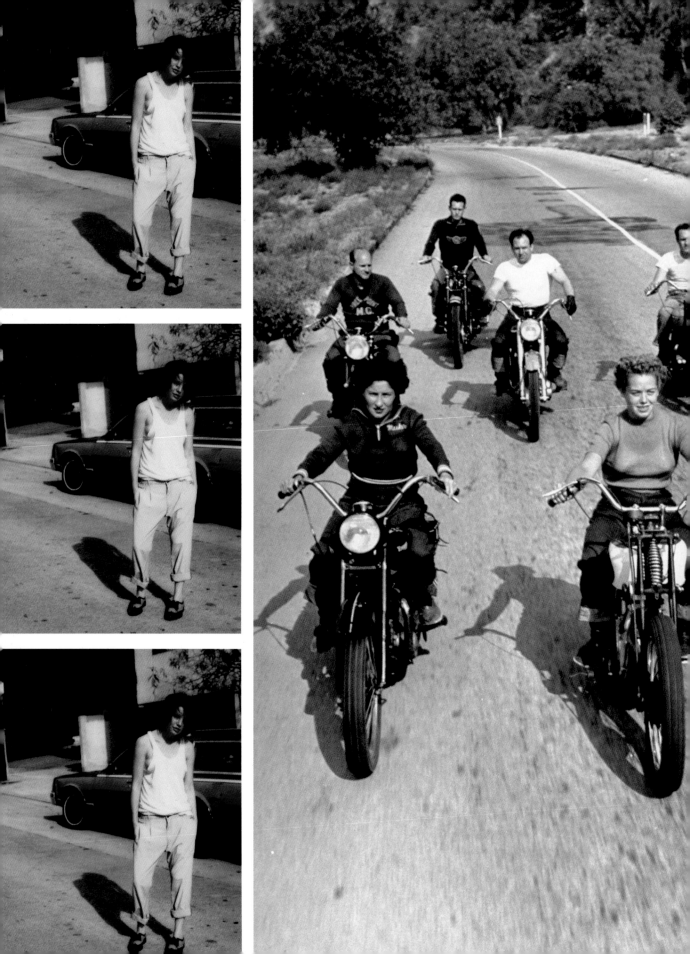

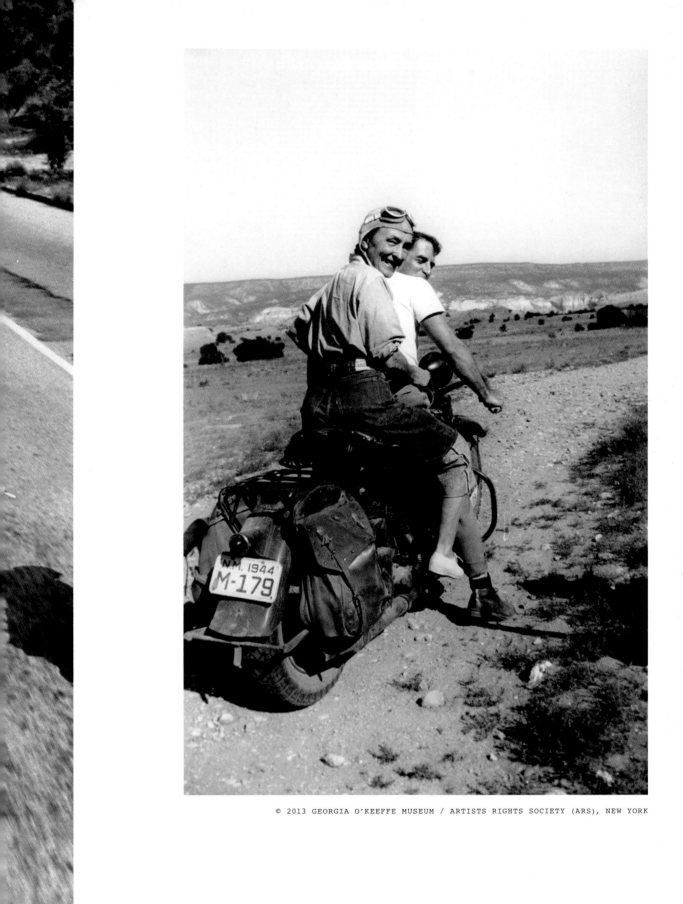

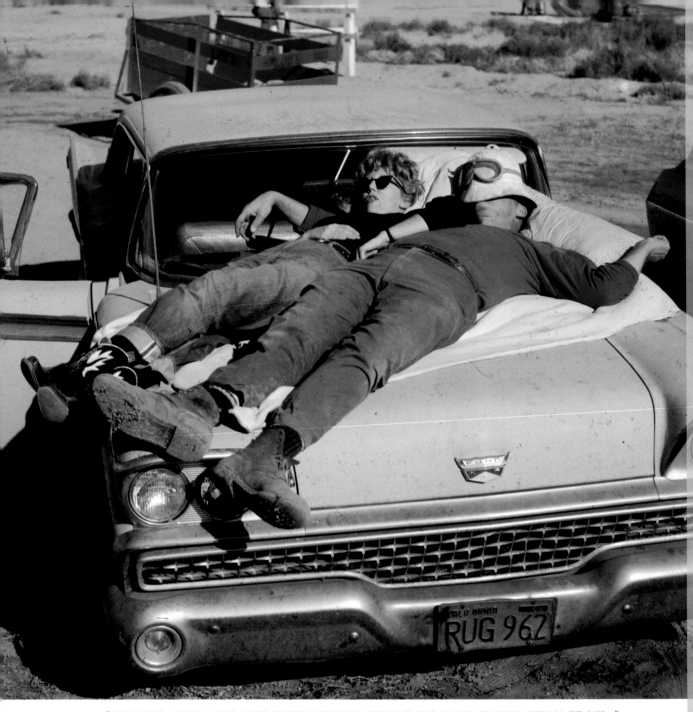

" THIS COUPLE, TAKING A QUICK, HAPPY RESPITE ON THE ROAD, REMINDS US THAT IN LIFE, WE SHOULD OFTEN DO THE SAME. "

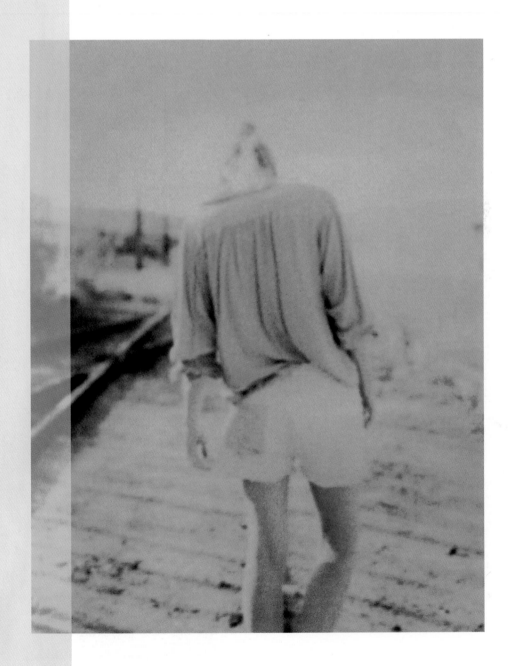

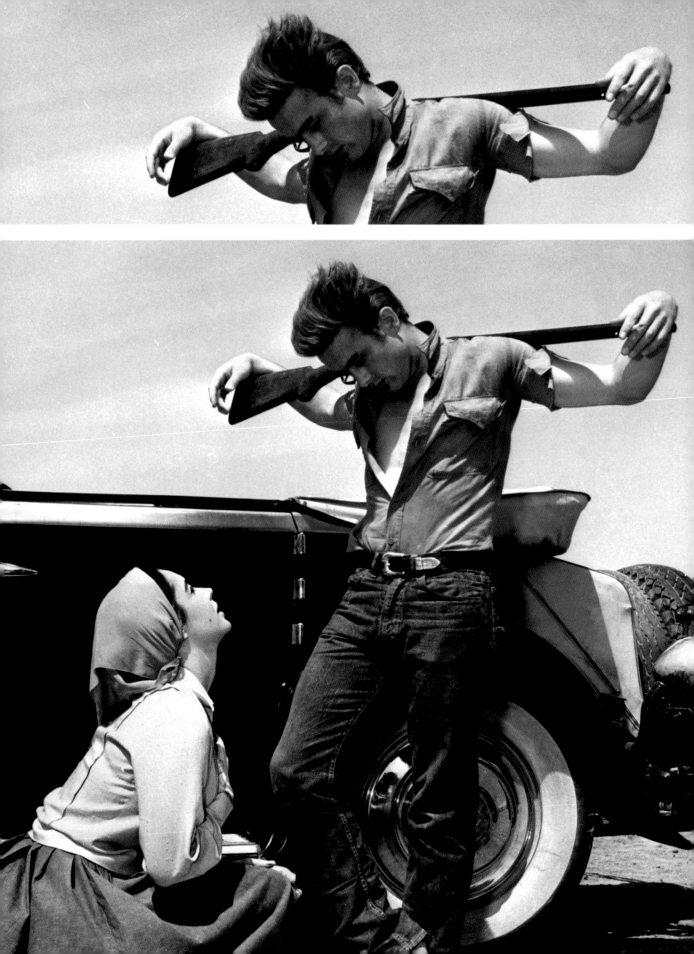

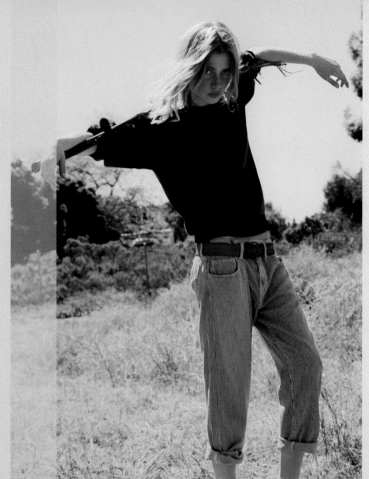

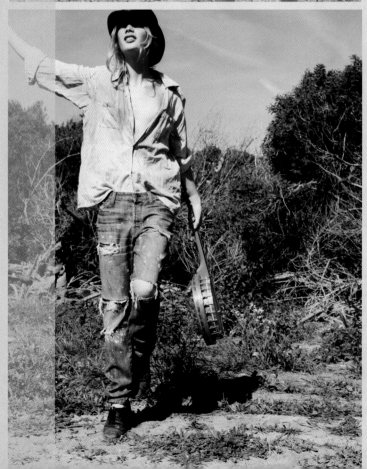

LIKE BLUE JEANS, THE LOVE AND CARE OF AN AUTOMOBILE IS A PILLAR OF AMERICAN CULTURE.

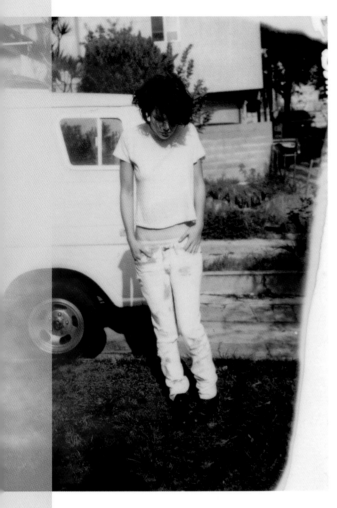

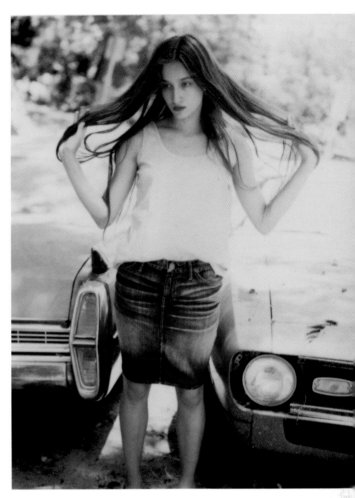

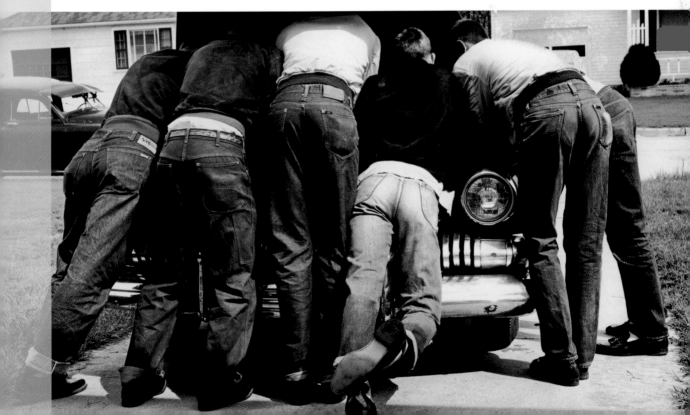

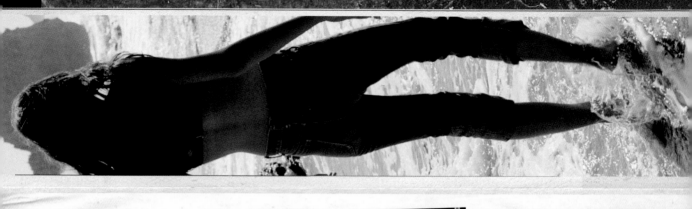

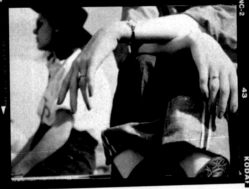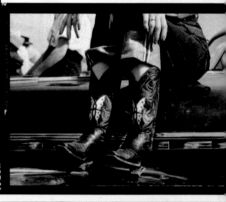

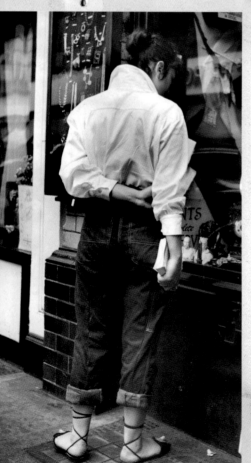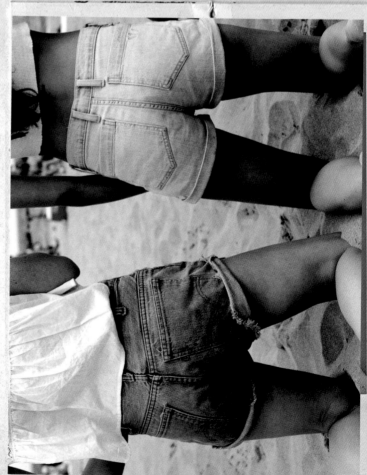

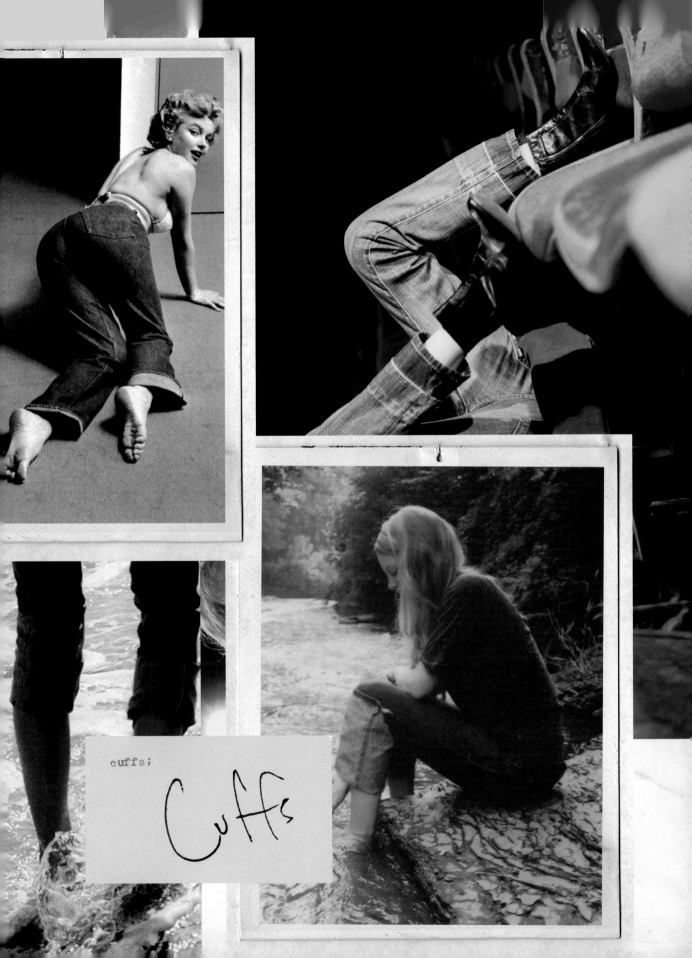

cuffs;

Cuffs

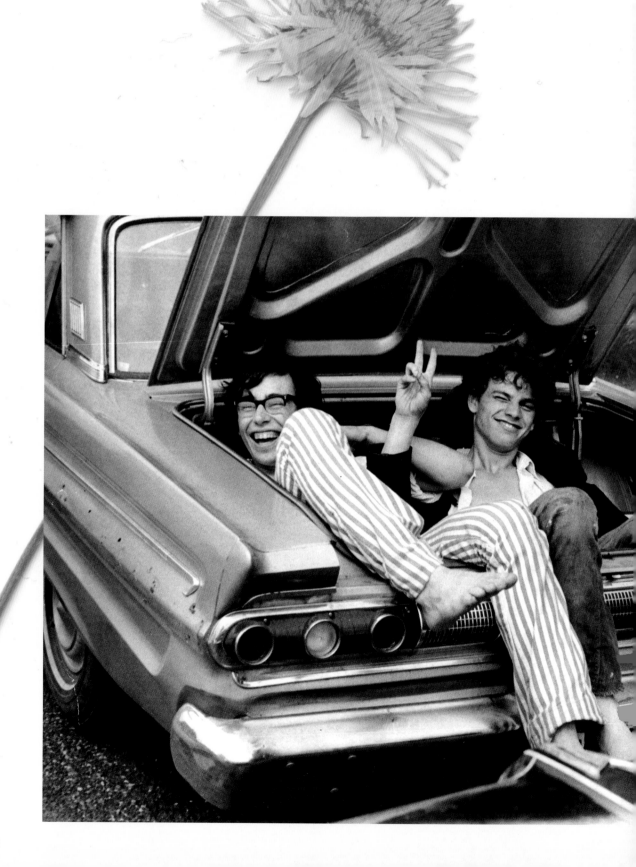

War & Peace

The notion of freedom is as American as apple pie and blue jeans. Whether it be Rosie the Riveter advocating women working during wartime, or hippies in painted and patched bell-bottoms, denim is the fabric of independence and self-expression. We love how a pair of jeans can make a statement, singing with joy or screaming with defiance. Jeans can be tight and purposeful or loose with sleepiness. We have loved collecting indigo that has seen protests and rallies, challenge and change.

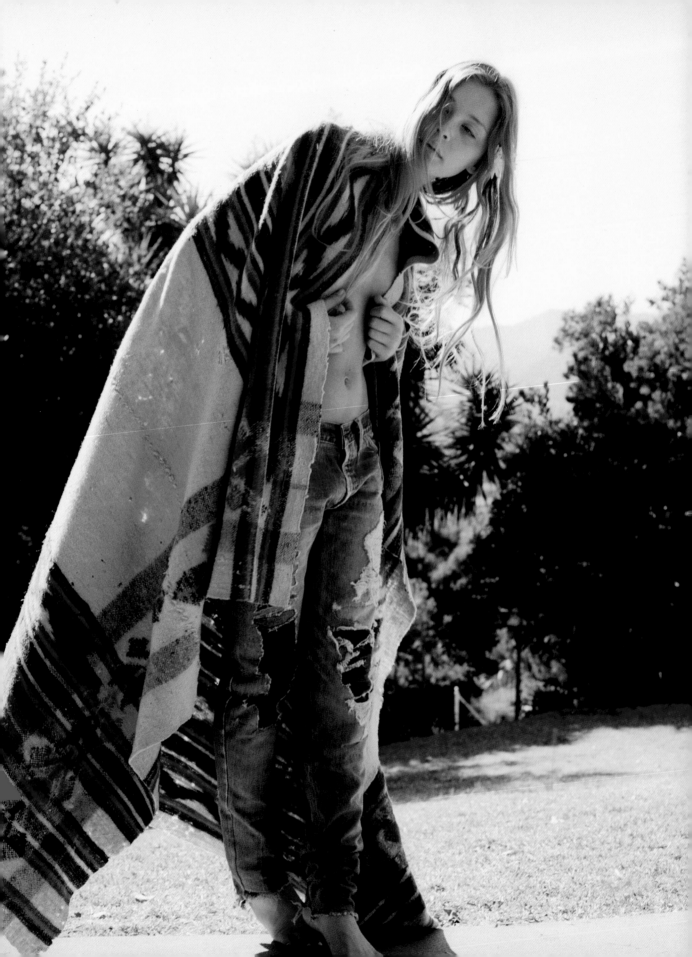

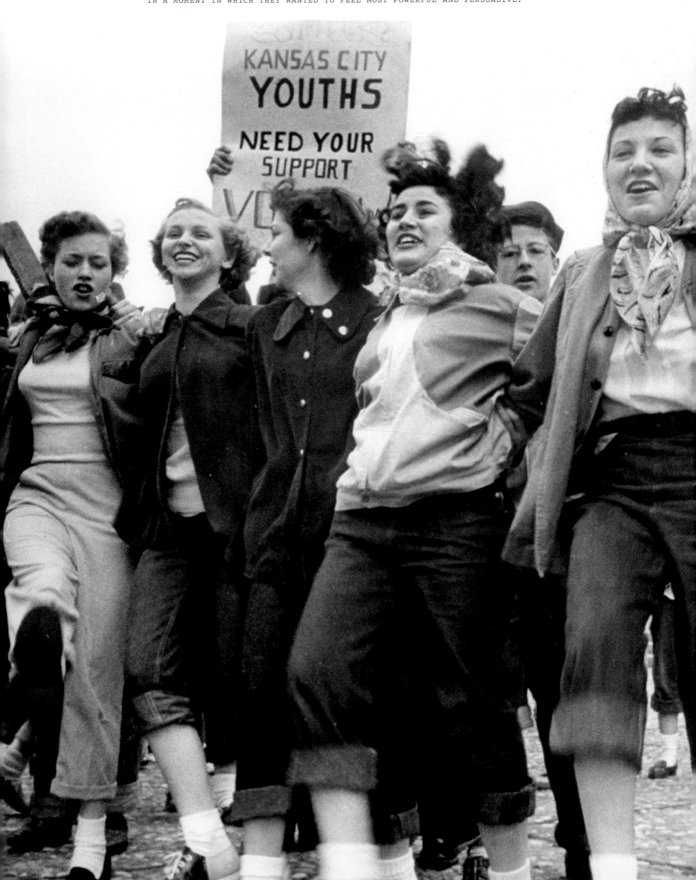

THESE WOMEN APPEAR TO BE DANCING AND MARCHING WITH BOTH HUMOR AND
FERVOROUS INTENT. IT'S OBVIOUS, AND NOTABLE, THAT THEY CHOSE TO WEAR DENIM
IN A MOMENT IN WHICH THEY WANTED TO FEEL MOST POWERFUL AND PERSUASIVE.

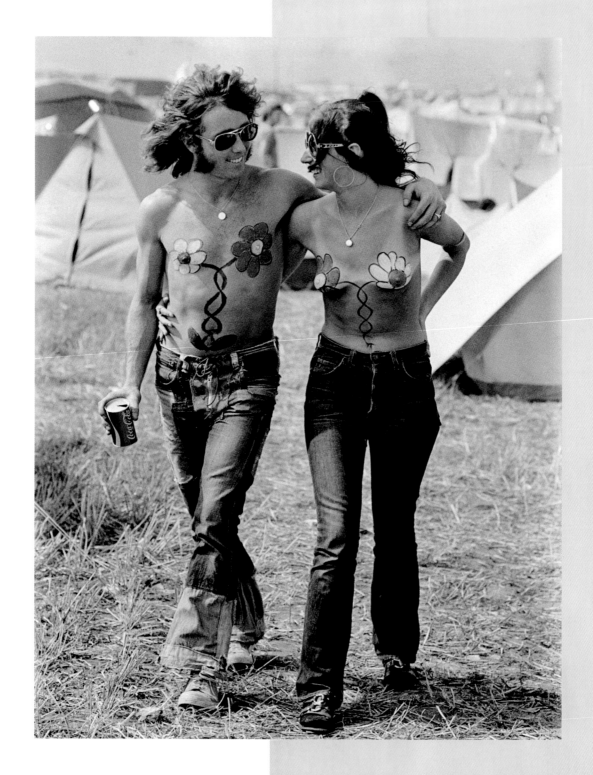

WE MET IN A SOCIOLOGY CLASS IN COLLEGE AND BECAME FAST FRIENDS-BONDING OVER A MUTUAL LOVE OF BELLBOTTOMS.
WE'D LIKE TO THINK THAT DENIM IS CAPABLE OF CREATING FRIENDSHIPS AND ENCOURAGING PEACE.

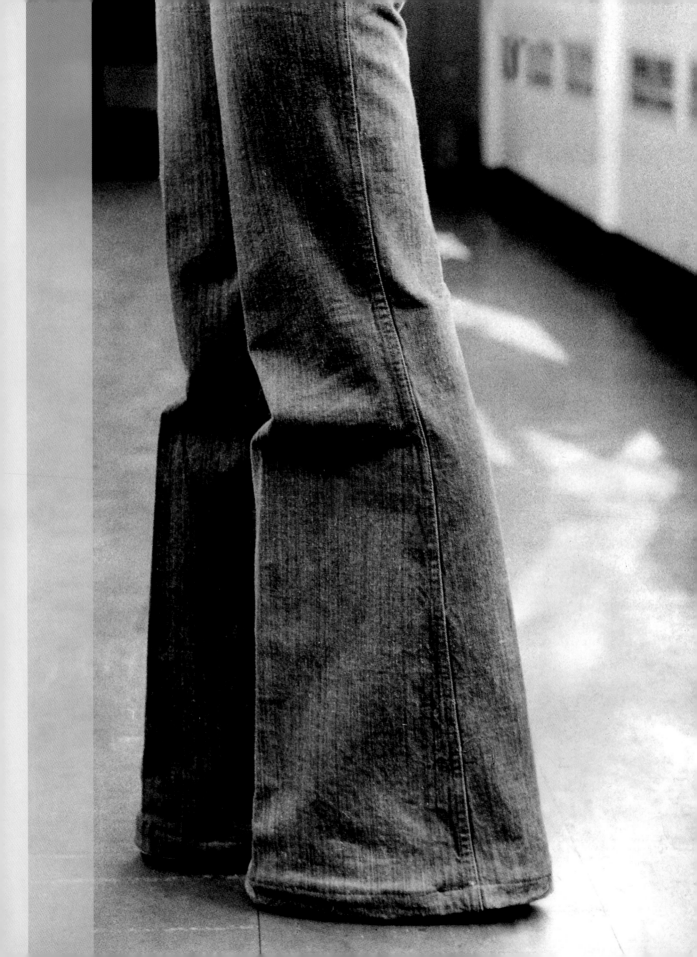

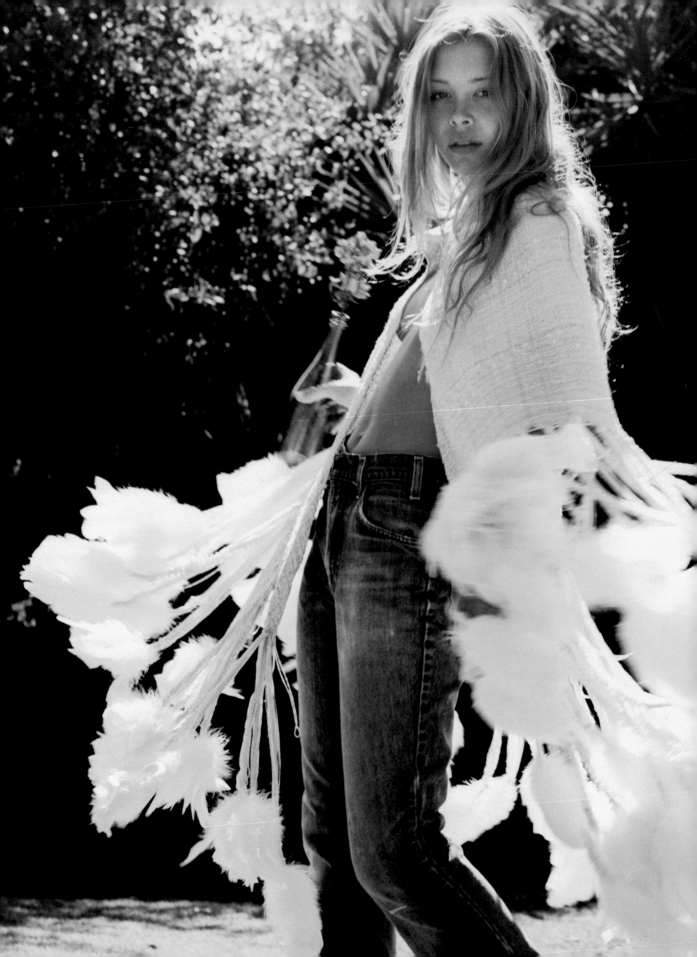

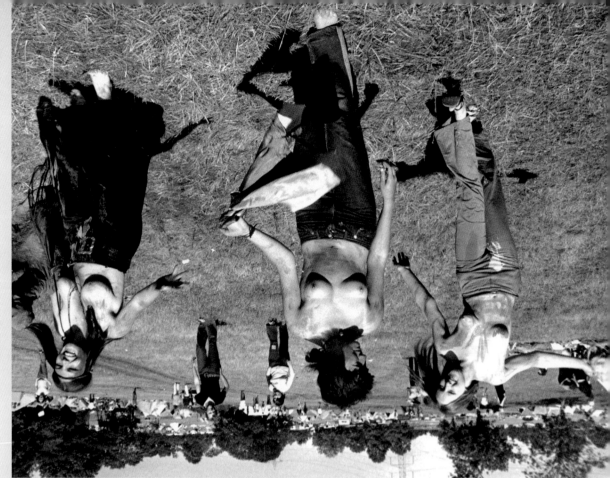

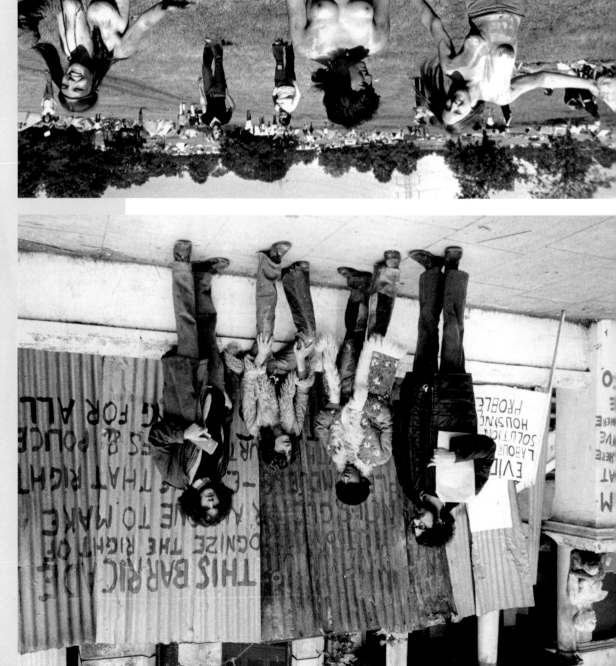

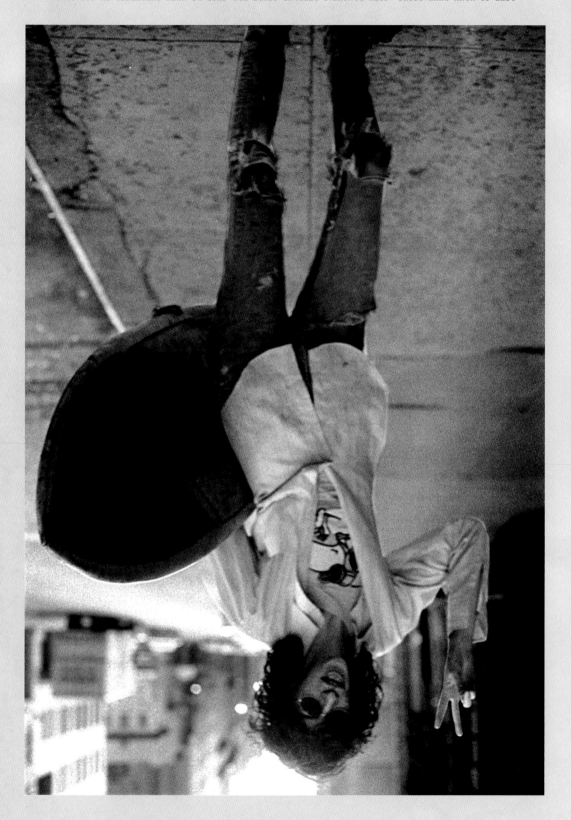

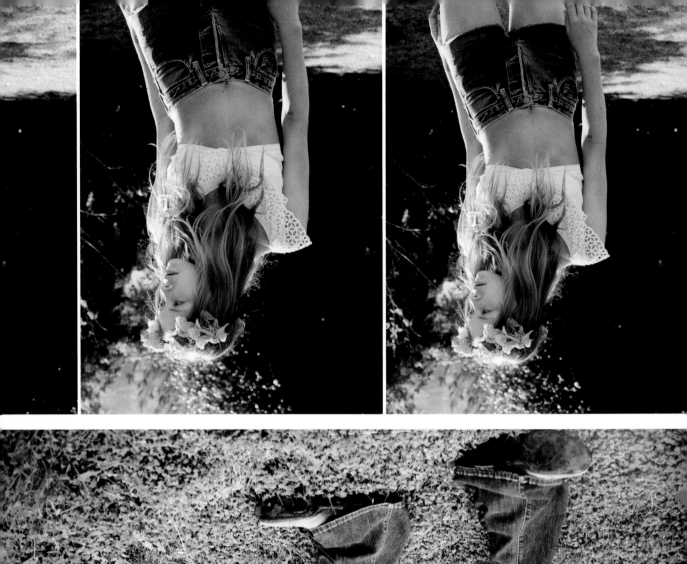
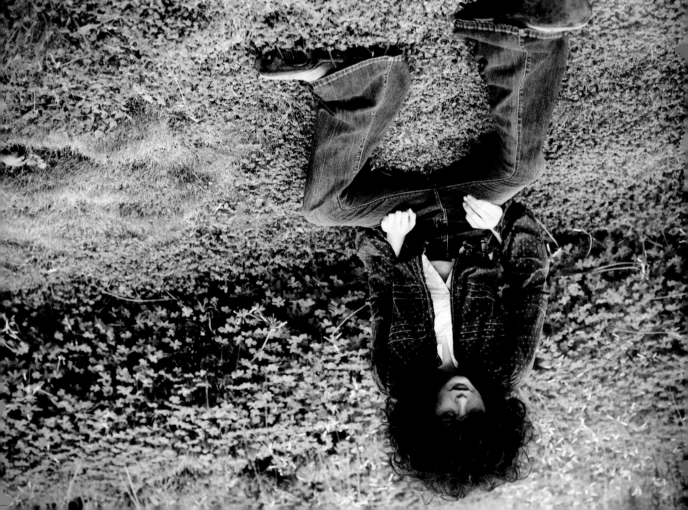

THE MICE SCURRYING ON THESE BELL-BOTTOMS
PROMPTED AN UNEXPECTED STILLNESS THAT,
WHILE STYLING THIS, MADE US APPRECIATE BOTH
THE DRAMATIC FLARE OF THE JEANS AND THE
CURIOSITY OF THE LITTLE CREATURES.

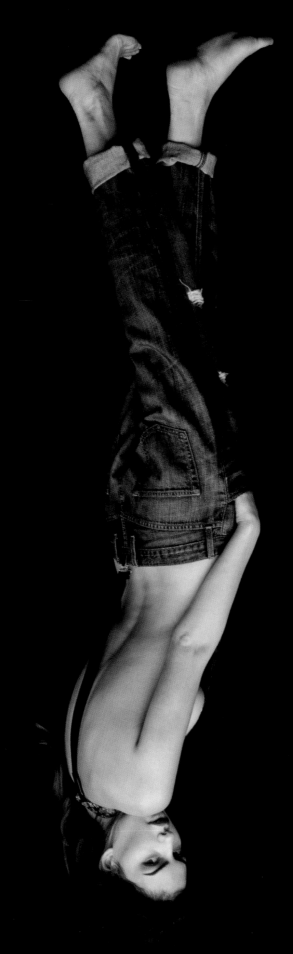

Boyfriend

In our own personal denim story the notion of
a boyfriend jean has been quite pivotal. We borrowed and stole
our boyfriends' and dads' jeans-pulling them low on our hips and
rolling them at the ankle to become our own. This baggy favorite has
weaved its way through history and into our own lives. We love that
it feels and looks easy, and is comfortable and feminine in the most
endearingly boyish way.

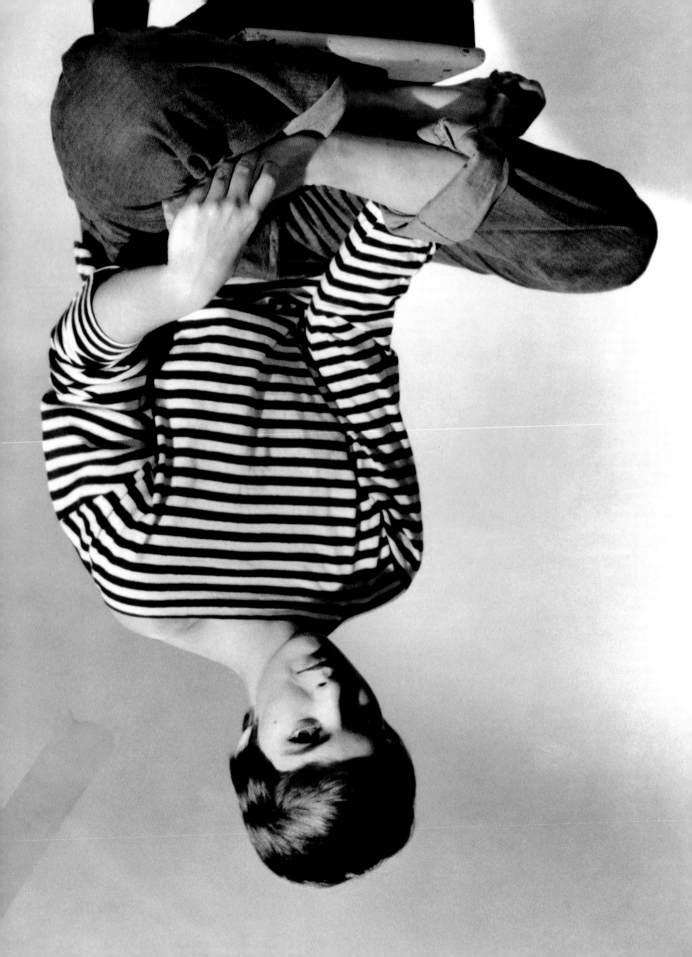

A BAGGY ROLLED JEAN MAKES EVERYONE FEEL CONFIDENT AND WISE, YET APPROACHABLE.
FROM CRISP AND RAW, TO FADED AND WORN, A BORROWED-FROM-THE-BOYS PAIR IS UNIVERSALLY LOVED.

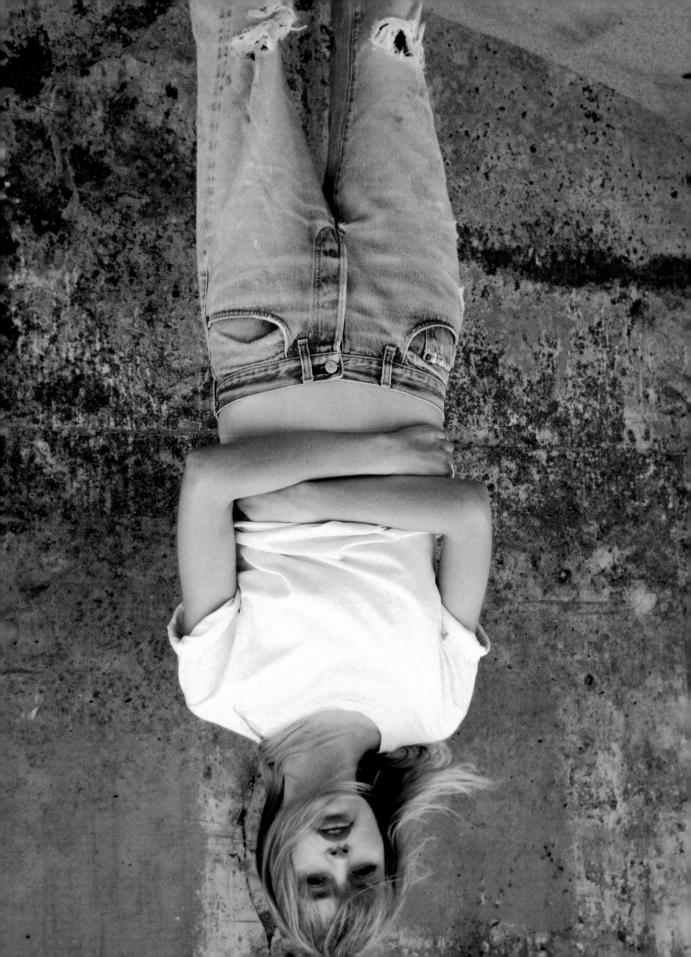

THE ROLLED JEAN TREND BECAME POPULAR IN THE
FIFTIES—MOSTLY DUE TO NECESSITY. AS JEANS
WEREN'T AS ACCESSIBLE AS THEY ARE TODAY, PEOPLE
OFTEN ROLLED OVERSIZED HAND-ME-DOWNS TO ACHIEVE
A WEARABLE LENGTH.

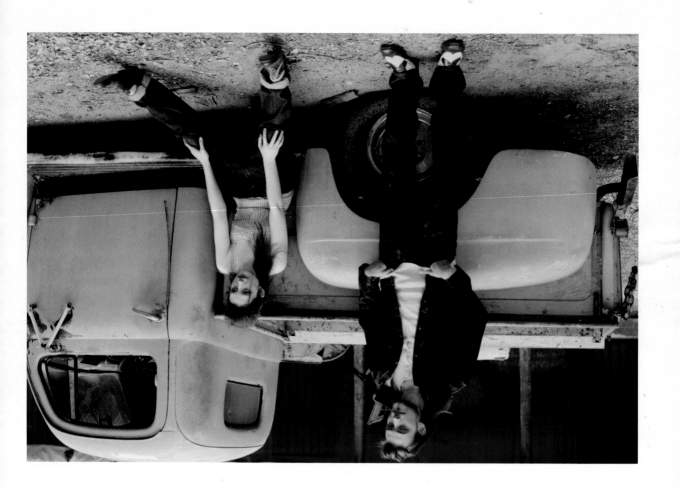

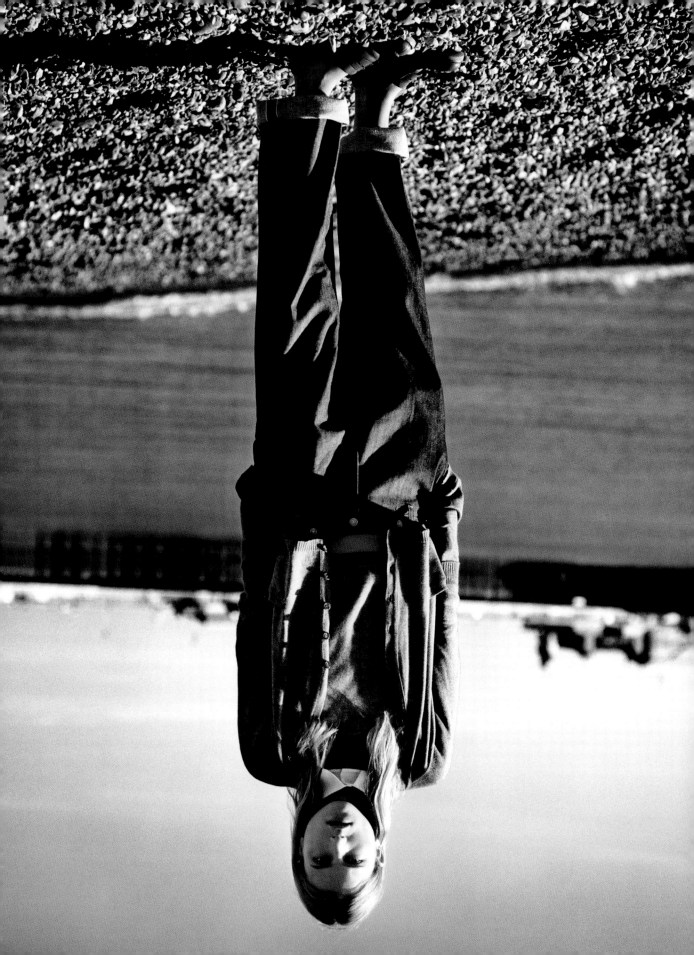

Index

a special thanks to:

Liz Browne, Sarah Chiarot, Lindsey Dupuis, Ron Goldie, Shay Neilson,
Ellen Nidy, Meghan Noyes, Brett Ramey, Ashley Ross & Lauren Urband

a heartfelt thanks to:

David Brotherton, Wallis Brotherton, Wayne & Linda Current,
Emmett Malloy, Henry Malloy, Augustus Malloy, Ginger & Michael Walsh,
John Rankin, Lyric Carlberg, Wolfe Rankin, Kevin Carlberg, Craig & Nancy Elliott

First published in the United States of America in 2014 by

Rizzoli International Publications, Inc.

300 Park Avenue South, New York, NY 10010

www.rizzoliusa.com

© 2014 Rizzoli International Publications, Inc

© 2014 Emily Current, Meritt Elliott, Hilary Walsh

2014 2015 2016 2017 2018 / 10 9 8 7 6 5 4 3 2 1

ISBN-13: 978-0-8478-4234-6

Library of Congress Control Number: 2013952715

Book design by Sarah Chiarot

Printed and bound in China

Distributed to the U.S. trade by Random House